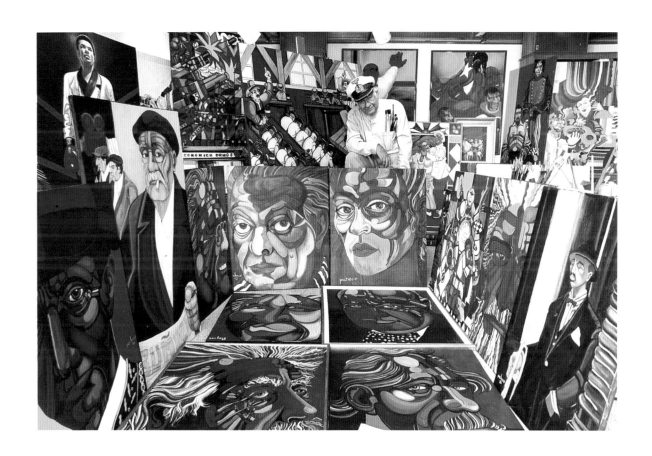

 Ferdie Pacheco

Pacheco's

Art of Ybor City

University Press of Florida

GAINESVILLE TALLAHASSEE TAMPA BOCA RATON

PENSACOLA ORLANDO MIAMI JACKSONVILLE

Copyright 1997 by the Board of Regents of the State of Florida
Printed by Milanostampa, SPA, Sarigliano, Italy, on acid-free paper

02 01 00 99 98 97 6 5 4 3 2 1

LIBRARY OF CONGRESS CATALOGING-IN-PUBLICATION DATA
Pacheco, Ferdie.
Pacheco's art of Ybor City / Ferdie Pacheco.
p. cm.
ISBN 0-8130-1517-0 (cloth: acid-free paper)
1. Pacheco, Ferdie—Themes, motives. 2. Ybor City (Tampa, Fla.)—
Social life and customs—Pictorial works. 3. Ybor City (Tampa,
Fla.)—In art. 4. Tampa (Fla.)—Social life and customs—Pictorial
works. 5. Tampa (Fla.)—In art. I. Title.
ND237.P155A4 1997
759.13—dc21 97-11190

Front cover: *Literary Disagreement,* by Ferdie Pacheco (1995).
Half-title and back cover: Ferdie Pacheco. Photo by Bob Gelberg,
copyright 1997.

The University Press of Florida is the scholarly publishing agency
for the State University System of Florida, comprised of Florida A
& M University, Florida Atlantic University, Florida International
University, Florida State University, University of Central Florida,
University of Florida, University of North Florida, University of
South Florida, and University of West Florida.

University Press of Florida
15 Northwest 15th Street
Gainesville, FL 32611

This book is dedicated to the artists, writers, lectors, journalists, and radio and television people who recorded our passing through Ybor City in the twentieth century. They kept the picture focused so I could paint it properly.

ço ço ço Contents

❧ ❧ ❧ Preface

THE PURPOSE OF this book is to illustrate what Ybor City, Florida, looked like in the good old days of the 1930s and '40s. It follows *Ybor City Chronicles* and *The Columbia Restaurant Cookbook* (with Adela Gonzmart) and finalizes my attempt to record our passage. This Ybor City triad of books is about the people who made that place great. Spaniards, Cubans, and Italians came together and worked smoothly to make Ybor City an exceptional place to live. My goal is to record how we lived; our workplaces, picnics, dances, political battles, and homes come to life on my canvas. I leave the recording of how buildings and streets looked to better painters.

All of my work is anchored in my memory of the "good ol' days," but it is also based on deep research. To all of the old folks I interviewed, I owe a debt of gratitude. Their crystal-clear memories form the backbone of this work. Everyone has their own Ybor City. These three books attempt to re-create one Ybor, a piece here and a piece there, of precious memory.

The list of professional help is long. Historians share a need to record our past as accurately and fully as we can. There is very little professional jealousy and a great deal of sharing information.

For Tampa history I turn to the twin towers of knowledge: Hampton Dunn and Leland Hawes. The *Tampa Tribune* files are always available through the auspices of Tom McEwen and young Joe Guidry, who holds the unenviable distinction of being the only man in Tampa who has read every book I've ever written.

Of course, the greatest source of Ybor City lore is Roland Manteiga, the son of the renowned lector Don Victoriano, and the publisher and editor of *La Gaceta,* the country's only trilingual newspaper. Roland's influence on me was profound, and I first started to write about Ybor City in 1980. More than any one man, Roland has kept the Ybor City story alive and continues to be a guiding light for all Ybor City writers.

Professor Gary Mormino of the University of South Florida has had more impact on my work than anyone else. Gary came to Indian Rocks Beach where I was writing a film script, whipped out a tape recorder, and drained me of my knowledge of Ybor City history in one long afternoon session. He and his co-

author, George Pozetta, ultimately produced *The Immigrant World of Ybor City,* an excellent history of Ybor City's Italians. What is more, I had found a kindred spirit.

When I started to write *Ybor City Chronicles,* Gary opened his voluminous Ybor City file to me. Here I found Dr. José Avellanal's original suicide note, Charlie Wall's death photos, bolita paraphernalia, cigar labels, and an infinite number of great *Tribune* articles on the bizarre foibles of the cigar factories. Gary Mormino and the history department at USF are dedicated to recording the Ybor City story. I hope that my trilogy will add to his collection and be looked at, used, and enjoyed by future students.

Finally, I continue to be indebted to my family: they are as committed as I am to producing an excellent Ybor City history. My wife, Luisita, continues her hard work of editing and typing my manuscripts. My daughter, Tina, chose Ybor City as the subject of her graduate thesis at New York University's film school. She spent a year filming old folks, who gave their histories freely, and to this she added a visual documentary of the area as it looks today. The film, *Ybor City Revisited,* is a terrific half-hour-long look at Ybor City, then and now.

It would be impossible to list all of the other friends and family who have been indispensable to this gathering of history. I feel my life is a giant rug made up of thousands of strands of Ybor City acquaintances and their stories. So, to all of you who have shared a moment or two with me, I ask you to let me share this book of memories with you. See if you can pick yourself out. You are in there someplace. Trust me.

∾ ∾ ∾ Ybor City A BRIEF HISTORY

YBOR CITY IS AN immigrant district of Tampa, Florida, many of whose inhabitants worked in the flourishing cigar industry in the first half of the twentieth century. They came from Spain, Cuba, and Italy seeking to become part of the American Dream.

By the 1930s and '40s the three nationalities had blended into an almost homogenous labor force. Each still maintained its national roots and characteristics, but their children benefited from the best of each culture to become Americans with distinctive roots. They survived the Great Depression of the 1930s and the trauma of the Second World War in the '40s. These are the days I remember fondly and which form the main thread of this book.

To understand what happened here as recorded by the paintings, I think you should know a bit of the history of that immigrant utopia.

THE BIRTH OF Ybor City was due to Gavino Gutierrez's need to find a place to grow guavas for his lucrative produce business, which was then located in Havana. In November of 1884, Gavino visited Tampa and found the weather perfect. What is more, Tampa boasted a deepwater port and a stretch of land available for development at an astoundingly low price. Gavino continued his search, however, taking his paddlewheel boat down to Key West, the other possibility.

In Key West he met Ignacio Haya, the owner of a New York cigar factory, one of the largest in the world. Haya needed to relocate his factory, La Flor de Sanchez y Haya, because of labor difficulties he was having in Key West. Together the men discussed the great possibilities offered by the Tampa land.

At that precise moment Vincente Martinez Ybor, owner of the successful Príncipe de Gales (Prince of Wales) cigar factory in Key West, was facing severe labor troubles: his Cuban workers were insisting on better working conditions and higher wages. Faced with frequent strikes, he chose to relocate.

The first of these three men to move their operation to Tampa was Martinez Ybor. After some hard dealing with Captain John Thomas Lesley and the Tampa Chamber of Commerce, Ybor purchased a large tract of land. To this he later added an adjacent tract owned by S. P. Haddon. Combined, these two made a sizable area that became Ybor City. Having contracted with Gavino Gutierrez to

come plan and build the new city, Ybor set his mind to building his factory. Ybor City was on its way to becoming the cigar capital of the world.

Among Ybor City's first inhabitants were the Spanish workers Ybor enticed to move from Key West to Tampa. These formed the nucleus of a large Spanish community which grew as its members sent for family and friends to come to the new world. A large number of Cubans were also ostensibly among Ybor City's first inhabitants, but here statistics belie the truth, for many an immigrant "from Cuba" was merely a transient traveler from Spain seeking access to the United States via Cuba, which was not then subject to U.S. immigration quotas.

With the advent of the Spanish-American war, Tampa became a focal point for media attention. Theodore Roosevelt encamped his volunteer cavalry unit, the Rough Riders, at Port Tampa. While he made a big pretense of enduring the heat, sand flies, mosquitoes, and snakes with them, he actually waited until lights-out and sneaked away to the sumptuous Tampa Bay Hotel to join his wife and spend the night in comfort. While Ybor City was off limits to his soldiers, Colonel Roosevelt took parties of officers, newspaper reporters, and visiting dignitaries to the Hotel El Pasaje there for long dinner parties. El Pasaje also entertained Richard Harding Davis, famous Spanish-American War correspondent, and later Winston Churchill.

At the turn of the century, another group of European immigrants arrived in Ybor City, and they were to play a major role in its development. Sicilians had been settling in New Orleans for years, but the mysterious assassination of the Anglo chief of police caused their hasty exodus. They fled to Ybor City, where they settled on the outskirts of the thriving community then called Pachata. Unofficially banned from work in the cigar factories, Sicilians sought their livelihoods in agriculture. In time they came to dominate the produce and dairy businesses. Later, when they had learned Spanish, they were admitted to the cigar factories.

The subsequent history of Ybor City is a riveting tale of labor relations, ward politics, bolita wars, gangsterism, and the growth and death of an industry. For our purposes, however, this brief history of Ybor City's early beginnings suffices. *Pacheco's Art of Ybor City* is my attempt at revisiting Ybor City at its peak years, when—in spite of the excitement surrounding us—all seemed golden, when its Spanish, Cuban, and Italian inhabitants lived a safe, happy existence, wrapped in a cocoon of comfortable familiarity. Three nationalities lived happily together and the goal of all immigrants was the same: to become Americans.

With each passing generation, the strong image of the first immigrants fades. Languages are lost; the customs, morals, social mores, and ambitions disappear. It is always this way in the sociological history of an immigrant society. This book is a serious attempt to preserve the sense of daily life in the Ybor City of my youth.

Today, Ybor City is a vestige of what it once was. The residential section, the vital life's blood of any community, no longer exists. The children of the first generation have moved out. The reckless and grossly erroneous practice of urban renewal destroyed the very heart of the immigrant community, leaving in its

path a vacuum of empty lots. The big buildings the immigrants so proudly built—the Centro Asturiano and the Centro Español, the Círculo Cubano, the Unión Italiano, the Labor Temple, the Columbia Restaurant, the Hotel El Pasaje, and the many factories—these alone remain.

With this brief sketch of Ybor City's history in mind, I feel you can better appreciate what I tried to capture in *Pacheco's Art of Ybor City.* My goal is not simply to create faithful representations of the buildings and streets, for I feel a photograph is infinitely superior to an oil painting in capturing such detail. For those so inclined, I particularly recommend the photography of the Burgert Brothers, whose official photographs for the City of Tampa are available in *Pioneer Commercial Photography* (University Press of Florida, 1992). I would also urge interested readers to visit the Tampa Public Library and go through their huge collection, which is readily available to the general public.

The purpose of these paintings is to capture the people of Ybor City as they went about their daily lives. I wanted to show the cigar makers working while a lector read aloud to them; a family having breakfast; and now and then a gripping event, as when two cigar makers disagreed about what novel a lector should read and then shot each other. Also, I hoped to show how the folks looked at various times, and not necessarily just in the 1930s. For example, the most famous lector, Don Victoriano Manteiga, is painted in his last years, crippled by arthritis, but still feisty and still fighting the old battles. I have painted his son, Roland Manteiga, the publisher and editor of *La Gaceta,* at the height of his career in the 1980s.

The history of Ybor City will never be a closed book. The children of that first generation of immigrants became senators, mayors, and, yes, even a governor of the state. Ybor City produced war heroes in abundance and a Medal of Honor winner. Great athletes have played in the major leagues. Many have scored successes in the entertainment world. The fields of medicine and law have honored many prominent Ybor City professionals for their high achievements. Men and women of accomplishment abound in the second and third generations of the hard-working Ybor City immigrant.

What is more, a wave of new investors have discovered the charm and uniqueness of Ybor City. Restoration of the old buildings is underway, and, given this renewed interest, Ybor City is beginning to live again. It will not be the utopia I knew as a young man; it will not be a happy ethnic enclave. But it will stand as witness to our journey, to a time when Spaniards, Cubans, and Italians came together in a wonderful mixture to become part of the American melting pot.

The history of Ybor City is rich. It is a mother lode of stories for novels, television, and movies—and for these paintings. So, it lives.

❧ ❧ ❧ The Artist A BRIEF AUTOBIOGRAPHY

PEOPLE WHO VIEW an artist's work seem to have a need to know about the life of the artist. I know I do, but I don't know why. A painting should stand or fall on its own merit alone. Nonetheless, I shall briefly detail a bit of my life.

My father, J. B. Pacheco, was a pharmacist from a long line of doctors and pharmacists, and I inherited their scientific genes. He married Consuelo Jimenez, daughter of Gustavo Jimenez, the Spanish consul in Ybor City. The Jimenez family had a broad creative base, so when I was born I inherited a strong band of genes for both my right brain and left brain. I suppose that this accounts for my fragmented personality and highly diversified life.

My involvement with art dates back to my earliest recollection. I was drawing a ship and penciled the year on its bow: 1933. I was six years old. Art, in those simple days, was a form of self-entertainment. My brother, Joseph, who was two years my senior, was an excellent artist, and I learned by copying him. He was in charge of all family artistic obligations, such as holiday and birthday cards. Joseph would create the beautiful card—my job was to sign it.

As we grew older and participated in school projects, I came into my own, and I discovered the felicitous relationship between art and the avoidance of physical labor. My mother was an industrious woman who never seemed to run out of things for us to do. In the steamy heat of a Tampa summer, nothing was as odious as yard work. The way out was art. My mother's side of the family esteemed creativity above all else, so everything else might fall by the wayside when an art project had to be completed. Is it any wonder that I came to love art?

The second stage of my evolving proficiency occurred in high school, where I developed a knack for satirical cartooning. My favorite cartoonist was a strange man named Virgil Partch, who appeared regularly in the *Saturday Evening Post*. I also loved the *New Yorker* humor, but it was too sedate, too clever, too chic.

My grandfather Gustavo Jimenez supervised our education in the serious artists. Among the Goyas, Rembrandts, and Velázquezes, there was one painter I was particularly drawn to, and for a very simple reason: I could copy him easily. That painter was Daumier, whose cartoonist art conveyed his biting social commentaries. I began to cartoon in earnest and found that it is a most wondrous tool.

Cartooning masks an insult with humor, or, if need be, pricks the balloon of the self-involved, the presumptuous, the windbag, the fool. And we've just covered a world of people: politicians, actors, critics, high-powered executives, and military figures, to name a few. In school I used cartoons with devastating effectiveness. They were all the more useful during my protracted college career.

My course of higher education was long, broad, and expensive. I attended five southern universities over twelve years, graduating as a pharmacist from the University of Florida, and then as a doctor of medicine from the University of Miami. Somewhere along the way I amassed enough credits for degrees in English, history, and philosophy. I was overeducated and underfed. Through it all, my cartoons were my surest weapon against fools.

During my medical internship days at Mt. Sinai Hospital in Miami Beach, we feared one surgeon in particular because of his violent behavior in the operating suite. He was abusive, profane, and destructive to his operating team. I spent one unpleasant day assisting him in a simple case. I couldn't wait to get to my sketch pad. The next day, when the surgeons came to the scrub room, they were met by six cartoons tacked to the scrub tubs at eye level. Great was the hilarity at the expense of the terrible-tempered doctor. He requested that I never again be assigned to his cases, and according to the nurses, he curbed his temper for a long while—at least until he saw me leave Mt. Sinai Hospital.

A deft cartoon can work like venom—or like sugar. Compliments flow through humor. People love to see themselves in a flattering light, their deeds recorded in a humorous glow. They frame your sketches and keep them for life on their walls. To this day I always send cartoons to people I work with. Some are sugar, and some acid.

Perhaps the most fortuitous use of an ability for line drawing and sketches is as a tool of seduction. In my era of being a fool for love, I shamelessly sketched every good-looking girl I saw. Leroy Neiman was my mentor in this regard. We had developed a long friendship because of Leroy's love of boxing, but he was also a terrific seduction sketch artist. Leroy gave me two rules about drawing girls when they are unaware that they are being drawn. One was to be patient if the girl changed her position. A person always returns to the position they are most comfortable in; therefore, they return again and again to the same pose. For drawing beautiful women, the second piece of advice was even better: "Never try to draw the end of the nose, just use two dots to represent the nostrils." I haven't drawn a nose in years.

When I met and married my wife, Luisita, the need for this form of seduction came to a close. Although freed from the tyranny of sex, I was hopelessly addicted—and to this day I still am—to drawing the beautiful women I see in cafés, concerts, athletic events, and (regrettably) funerals. The difference is that I no longer talk to my subjects, and I have my wife hand them the drawings as I leave. It's safer that way.

As I progressed through my university life, I went to as many galleries as I could and discovered the pleasures of fine-art books in the libraries. In my sixth

year, in pharmacy school at the University of Florida, I struck up a friendship with a veteran studying on the G.I. Bill whose major was art. It seemed incidental to him that he had no talent for it whatsoever. He invited me to visit him at the studio in the evenings, when he worked on the one painting he would produce that year. He was painting a kerosene heater. It did look like one, I'll give him that. The unexpected bonus to this acquaintance, however, was that I met his teacher, then the artist-in-residence at U.F., Fletcher Martin.

In Fletcher Martin I found a role model. His paintings were exactly like what I wanted to do. They were almost cartoonish, but full of energy and color. He introduced me to the school of the muralists of the 1930s. Through Fletcher, I discovered Thomas Hart Benton. Something crystallized in me. I felt I had found a style I could use, a style that could tap into a deep sense of humanity and still include an element of humor.

In the postwar era, the preeminent American illustrator was Norman Rockwell. I loved him, but he bewildered me. Look at his picture of a barbershop and you see that the floor is made up of thousands of octagonal tiles. Rockwell paints each one perfectly uniform. His exactitude exhausts me. Still, I love the feeling and humanity of his paintings. That Rockwell is not considered a fine artist, but an illustrator, I can't agree with. He was a fine artist and will be remembered as the painter who best defined America in the 1930s and '40s, when we slumped through the Depression and united to preserve our country in the Second World War.

The University of Florida had a fine history department, and one summer, with electives to be gotten out of the way, I took a course on the history of Mexico, taught by a paratroop colonel. What came out of that wonderful summer was my discovery of Mexican art.

If the American muralists represented exactly the kind of art I felt I could produce, then the Mexican artists drove me to a higher level. The art of Diego Rivera fit perfectly my idea of what art should be. The color of Rufino Tamayo and José Clemente Orozco blinded me and filled me with a desire to use vivid colors. Their use of strong design inspired me, and I found their treatment of themes like the Conquista of Cortés and the Revolution of 1910 to be masterpieces of aggression. They fit my aggressive nature and made me want to try their style.

In spite of all my seething desire to get to a canvas and start painting, however, I was in the midst of a higher pursuit: I was busily at work getting my M.D. degree. This consumed my time and finances, and precluded any frivolous expenditure on things like art supplies.

I had long appreciated the Impressionists, with Van Gogh and Gauguin being my favorites. Once again, their style made sense to me because I understood their craziness and their departure from the established classical styles. Rebels! My kind of people.

By the time I had reached a point when I was able to afford the time and money to paint, I was in my mid-thirties. In addition to having a time-consum-

ing medical practice, I had gotten involved in championship boxing and had become Muhammad Ali's personal physician. The advantage to my art was that boxing took me to the capitals of Europe and Africa, Asia, and South America. Now my art education became truly extensive. I would go to Diego Rivera's house and museum and return to paint my impressions of what I had seen. During this period I taught myself art by copying the actual paintings I loved. Mostly I picked representational painters to copy. I can still do a good Van Gogh, but I can't come close to Rembrandt and that lot.

By the time I turned fifty, I had pretty well satisfied all of my goals as a physician. It was 1980 and my charity clinic in the Miami's Overtown section had burned down in the McDuffie race riots, which started over the death of a black man who had been arrested and beaten to death by white policemen. I had also, by that time, closed my Cuban Exile Clinic. I had left boxing for good, walking out on Muhammad Ali when he refused to quit boxing and thereby incurred fearful damage to his health. I was at a crossroads.

With only my creative abilities to maintain my family, I worked for NBC-TV Sports as a boxing analyst and executive. I also published my first book, *Fight Doctor*. I decided to turn to art—one of my sustaining passions over the years—as a means of supporting my family. Serendipity, that element so important in my life, favored me again.

It was the 1980s, and greed was in favor. Morals slumped to new lows in the financial community. Anything was OK so long as you didn't get caught. The government threw some fuel on the fire when it came up with various tax shelters which, besides helping businesses evade taxes, were also supposed to encourage things like medical research and the arts. All of a sudden, greedy businessmen were taking an interest in things like chicken embryos and oil paintings.

One day, my good friend Howard Gordon, a prominent plastic surgeon, brought an unusual man to lunch. The man looked like a junkie Mark Twain. As it turned out, he was a funny, likable, manic, fast-talking salesman who had stumbled into tax shelters. He was tired of chicken embryos, though, and was looking for a safer long-term tax shelter.

Why not art? By dint of this improbable turn of events, I created over 600 images, which were each then reproduced 500 times in a signed and numbered edition. They sold like hotcakes. I was soon established throughout the country.

During the years of the tax shelter frenzy, I perfected my style while making an astounding sum of money. The end came suddenly when the U.S. government reversed itself, ruled tax shelters illegal, and demanded the money back, five years retroactive. Great was the wailing and gnashing of teeth among the greedy. The realization that they were going to have to pay their taxes after all came as a rude shock. But I had my start.

In the process of developing the style I favor for rendering faces by putting together blocks of vivid color, I was also perfecting my "people's art" style, a style synthesized from the works of Fletcher Martin, Thomas Hart Benton, the Soyer brothers, Don Cadimus, Diego Rivera, Rufino Tamayo, and José Clemente

Orozco. It was this combination of styles that predominated in the many exhibits and one-man shows where my works appeared world-wide during those years.

Art critics seem to stretch themselves out of shape seeking distinctions between people's art (as in Norman Rockwell) and fine art (as in Rembrandt). Many an art scholar has written learned treatises on the difference, but I tend to see things in a broader sense.

To me, art is art. When it works, it is the combination of several things. The first and most important is that the artist has succeeded in placing himself heart, eye, and soul into the painting. Like a jazz solo, the work must be representative of the inner self of the artist. Anyone can copy. It takes an artist to invent, to put himself on canvas. The second important thing is the development of a style of painting that is unique. This can be said to have happened when the public is able to identify a painting as "a Picasso," or "a Dali." Third is the marriage of painter and viewer. It can be measured proportionate to the amount of emotion generated in the viewer. The quality of the emotion does not matter and can range from love to hate, so long as the art has evoked an emotional response in the viewer. When you have managed to satisfy all three requirements, then you have a successful piece of art and can consider yourself an artist.

The artist is a distillation of all he has lived, been taught, seen, and all that has affected him in his lifetime. The main ingredient is God-given, and that is a *talent* for painting. Talent cannot be taught, it is given. Anyone can be taught to paint, and almost anyone can be taught to reproduce what they see. These are quasi-painters. The art world is full of these. But in every era, there are the few artists who stand out. They see things in a different way, they reproduce *their* reality. A photograph reproduces life as it is; a painter, life as he sees it.

Since 1980, I have followed the creative road. This is the sixth book I've published. I've sold eight movie screenplays and one musical play, which starred Petula Clark and ran on London's West End. My television career has been marked by two Emmys, and I continue to do expert boxing commentary for Showtime Television.

The reception of my art has been one of the most gratifying aspects of my varied career. I've exhibited in one-man shows and museums in New York, London, Paris, Marseilles, Miami, Tampa, Scottsdale, Phoenix, and Las Vegas. One of my works was awarded a gold medal in Tonneins, France, and I was singled out for my use of color and design at the Luxembourg Museum of Paris.

This book represents the realization of one of my dreams. As a historian and an artist, I've always wanted to use the best of both fields to produce a work that tells my particular story. This book is it. This is how I lived, and this is how I remember my life in that wonderful immigrant utopia, Ybor City.

Pacheco's Art of Ybor City is the third in a trilogy of Ybor City remembrances. My early, happy years in Ybor City are recorded in *Ybor City Chronicles* (University Press of Florida, 1994). *The Columbia Restaurant Cookbook* (University Press of Florida, 1995) outlines the ninety-year history of that famous eatery and records the biography of its remarkable seventy-four-year-old proprietress, Adela Hernan-

dez Gonzmart. Besides recipes from the restaurant, the book also includes many stories of its famous customers and of the unique Columbia Restaurant family.

For those of you interested in knowing even more about this artist's life, I refer you also to my first autobiographical book, *Fight Doctor* (1976), to *Muhammad Ali: A View from the Corner* (1992), and to my forthcoming autobiography, *The Doctor Fights Back,* which covers the years of my medical practice in a black and Cuban ghetto in Miami during the McDuffie race riots.

None of this could have taken place but for the support, help, love, and attention of my partner in life, the lovely Luisita, my wife for a happy twenty-five years. Suffice it to say that before I found her, I had not produced one book, not one screenplay, not one salable painting, nor had I the nerve to work in television. Her contribution to my life is inestimable.

Pacheco's Art of Ybor City

Diego Rivera

1992 · 30 X 36

For years I refused to do portraits. Normal people want an accurate representation of what they look like, done in a flattering light. John Singer Sargent said it best: "A portrait is an exact likeness of the subject, with something a *little* wrong with the mouth." The portraits I include in this book were not commissioned; they represent my own perception of each subject and do not depend on the subjects' approval.

I developed this unique style of portraits in order to paint my heroes. This painting of Diego Rivera is a good example of the style of painting that I employ. My subjects are people I admire in history and include Robert E. Lee, Gandhi, FDR, Manolete, Albert Einstein, Duke Ellington, Frederick Douglass, José Martí, and Abraham Lincoln, among others.

In simplest terms, Pacheco has used color to create form and volume, and has not relied on methods of line and value change.

While this is not necessarily a very unusual approach, there is much more involved.

First, he uses color from totally opposite sides of the spectrum, in juxtaposition, thus creating an almost fauve-like mask that has been lit for the stage or still photography.

Second, he uses the color in design patterns that literally carve their way through the facial structure like molten lava running down the sides of a volcano.

The effect is both startling and dramatic and [constitutes a] wholly personal approach to the sometimes predictable world of portrait art.

MURRAY GABY, "THE PACHECO FACES"

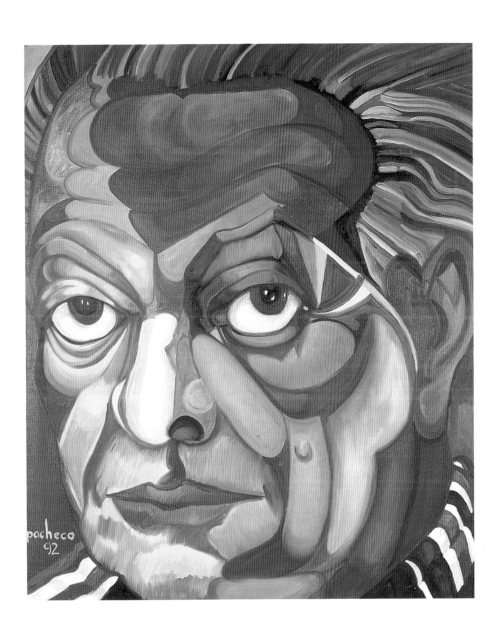

The Cigar Factory

1995 · 72 x 48

Cigar factories were originally large, wooden structures, which were unheated and uncooled. Many were two stories tall, and they were located all over Ybor City. Then, on March 1, 1908, a gigantic fire spread through Ybor, consuming most of these first factories.

The result of that fiery disaster was that factory owners rebuilt using red brick. One of the biggest and most beautiful of the new factories was the Regensberg, on the corner of 16th Street and Columbus Drive. The owner sent off to Germany for a huge, four-faced clock, which he installed in the tall watchtower and which tolled the hours and the half-hours. Most of Ybor City woke up to the sound of that clock and went to sleep by its accurate tolling. We who grew up in that era were doomed to a life of punctuality because of that clock. The Regensberg was also the tallest building in Ybor City. Anyway you looked at it, if you lived in Ybor City, the Regensberg Factory was a presence in your life.

So it was perhaps not surprising that when I began to write a novel about the factories and the lectors of Ybor City, I chose the Regensberg as my setting. In the novel it is referred to as "El Reloj" (the clock), which was how the citizens of Ybor referred to the Regensberg Factory.

Most fiction is anchored in autobiography. In this case, El Reloj was situated across the street from my father's drugstore, La Economica. For all the years we owned the pharmacy, our fortunes were tied to the factory and its workers. It was a building I knew very well, inside and out.

The first painting of the factory I ever did was at opening time. It is a large painting (72 x 48), and it captures a pivotal moment in the novel, depicting many of the characters who play a part in that tale.

On the right side of the canvas, a Michigan streetcar delivers the *tabaqueros* (cigar makers) to work on time. The yellow Birney streetcars were the most dependable form of transportation for Ybor City workers in the tough 1930s. Stepping out of the streetcar is a pretty cigar worker, aided by the ever courtly lady's man, Dr. Moreno. Behind him, some young workers make fun of his good manners.

In the foreground, Miranda has set up his canopy for selling his deviled-crab croquettes to workers who have missed their breakfast. Miranda's customers had to have cast-iron stomachs, for his crab croquettes were eaten with a liberal sprinkling of Tabasco sauce. Miranda never missed a morning, lunch, or closing of the factory. He put six strapping boys through college, so I suppose he knew what he was doing.

Beyond Miranda is the rock candy man. He was a mysterious, quiet figure. When he spoke it was with a German accent, which gave rise to many speculations about his origin and purpose on the street. I never did find out who he was, but—full of well-intentioned patriotism (this was during the Spanish Civil War and World War II)—I never bought any rock candy from him. My dentist tells me this contributed to the good health of my teeth, which proves there are benefits to be gained by being patriotic.

The dour policeman standing in front of the palms is actually one of the book's dark villains. He was called "Gator," and some said his dark color was due to the fact that he was part Seminole Indian. I thought it was due to his pent-up homicidal desires.

The focus of the painting is the drama being played out on the staircase. At the top of the stairs, the owner, Taliaferro, checks his watch with that of Pendas, his faithful foreman. Pendas has been the heart and soul of the factory, but feels caught now in a dispute between the owner and the workers.

At the bottom of the stairs, Fraga, the tough union leader, has just delivered the lector, Don Emiliano, in a red Model A roadster. The *lectores* (readers) in the cigar factories were employed to read to the workers as they made cigars, but they also served as a general source of news and information. Here, workers crowd around the lector to hear news about the bombing of Guernica. Many have families there and hope to hear of their fate. A disagreement between Don Emiliano and Taliaferro has reached its climax. If the lector continues to speak out in support of the Loyalist cause and in favor of better working conditions, he will be banned from reading to the workers. In this painting, I attempt to capture the emotion of this moment, just before the start of the day's work.

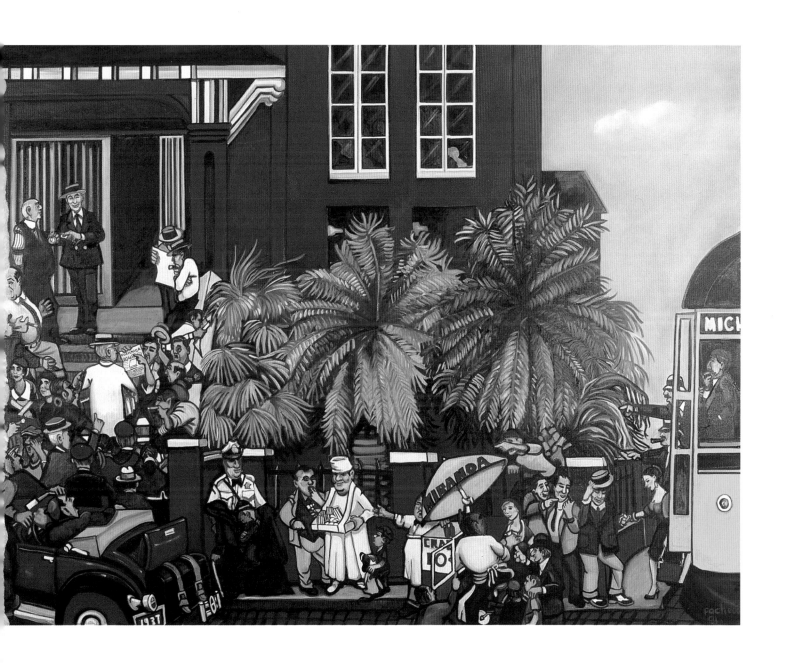

To Tell the World: The Lector

1993 · 48 X 54

Once inside the factory, the *lector* (reader) ascends his podium, selects his reading material, and begins to read or to lecture the workers as they bend to their task.

My goal here was to catch a cross-section of the workforce in different tasks and using the full variety of tools used in such factories. The lector is the focal point of the painting, and he is reading from a Victor Hugo novel.

On the workbench are the tools of the cigar maker. Work was measured and paid by *ruedas,* or wheels of finished cigars. Most commonly, there were fifty cigars to a wheel. A good cigar maker could make three wheels in a day.

Next to the wheel is the press used to mold the cigars so that they are uniform in shape. Next to the press, we see rough cigars whose ends have not yet been cut and shaped. The cigar ends were cut by a *chaveta* (knife) and glued together with an aloe solution. The cigars were then trimmed and placed in the molds, which were then stacked one upon another.

The heterogeneous mix of workers is apparent in the scene at the center of the painting. A pretty young Spanish woman works next to a mustachioed Sicilian, and a black man hovers next to them. The black workers were not African-Americans but Cuban blacks. The man in the Panama hat is a Cuban worker. All styles of hats were worn by the men. The most popular was the straw boater, but Spaniards liked *boinas,* or berets, and Cubans liked Panama hats. Many chose the American felt hats.

By the window we see an *escojedor,* which literally means "a chooser," selecting the right kind of tobacco. The best of the *escojedores* were women—and why not? Haven't women always had the last word in choosing quality?

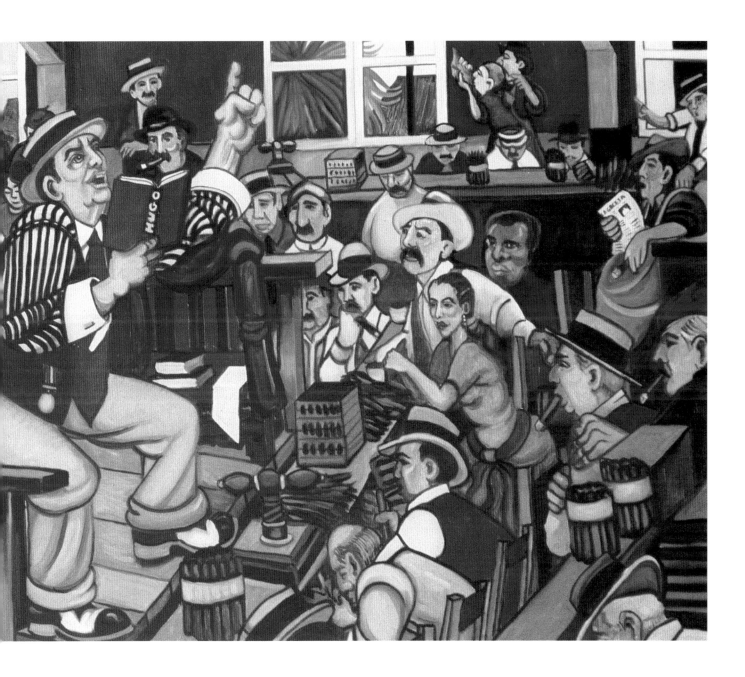

Literary Disagreement

1995 · 50 x 60

I chose this large painting for the cover of the book because of its design and color.

In something of a departure from the style characteristic of most of the paintings in the book, I intentionally designed a factory scene that allowed me to emphasize form as well as a strong color component.

The difference is in the line of the workers. They are automatons, each bent over his work at exactly the same angle as the others. They are dressed uniformly. Each wears the favored straw boater and a white shirt, and each has a cigar clamped in his mouth. The row facing the viewer is dressed similarly, but these workers have pinkish undershirts. The beams and supports function geometrically, cutting a plane across the windows.

But, since the Latin character does not lend itself to regimentation, one worker pops up to challenge the text being read by the lector. The lector is deeply immersed in his reading of *Nana,* by Emile Zola. It was not unusual to have a feisty worker take issue with the text. With the reading, never; with the text, always.

Now comes a moment that always mystifies me when I speak to the public and to art critics. The critic's perception of what an artist is thinking when he paints a figure always amazes me. Let me illustrate.

This painting had a big space in the right corner that seemed to need something, or someone. I was once told by an art critic that I "did corners well." That was all I needed to hear. I was determined to live up to that high praise. I bear down hard on corners.

The factories periodically passed out small cups of high-octane Cuban coffee. *Café solo,* as it was called in simpler days, cost a nickel. Now it is called expresso and costs $1.25. Such is the price of higher education.

A jolt of this stuff got the workers juiced to superhuman performance levels, so the owners were happy to distribute the small cups of black rocket fuel periodically throughout the workday.

Well, now for the empty corner. I added the *cafétero* (coffee man) with his tray of demitasses and blue pot of coffee. I was happy, and my painting was complete. The art critic agreed: "You never miss a chance to inject some humor in your work. Look at this delicious scene. A lector is in the midst of a dramatic reading, and yet a worker gets up to order a cup of expresso, not caring whether he is disrupting the reading."

I debated whether to change the title of the painting from *Literary Disagreement* to *One Coffee, Black, No Sugar.*

In the end I stuck to my original title. What do you think?

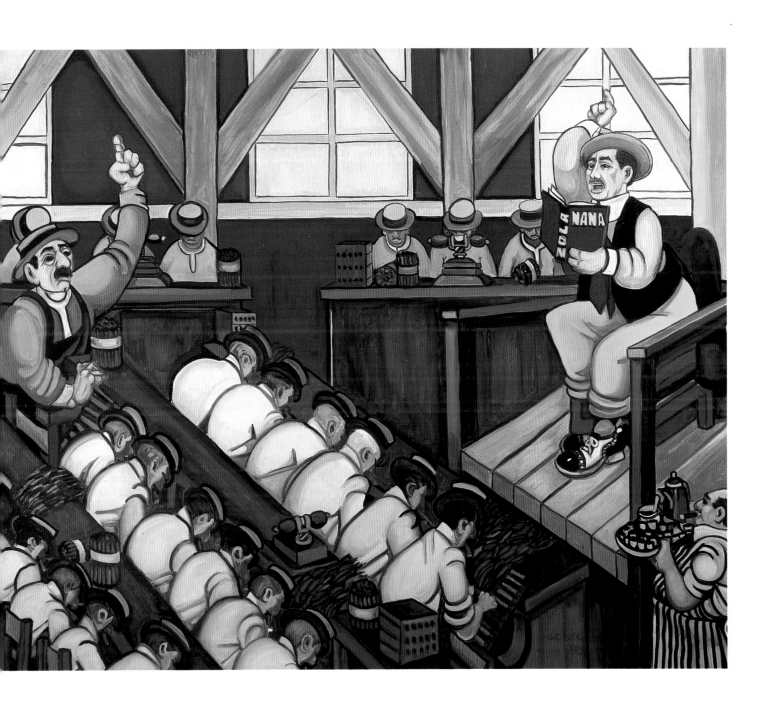

The Lector in Winter

1995 · 30 x 36

Lectors were considered a necessity at first by the owners, who wanted their workers to be entertained during the long, dull day of toiling at a routine task. Much later, the owners came to view them as a danger. Between one point and the other there lies an epic tale. This is the theme of my 800-page novel, *The Lector,* and this is why I consider them so interesting to paint.

Lectors came from the cigar factories of Havana and Key West. They were educated men who had great acting abilities and a vast capacity to entertain and educate. The great ones, such as Don Victoriano Manteiga (see p. 17), El Mejicano, Abelardo Díaz, Manuel Aparicio, José Rodriguez, and Horatio Henry Dominguez, worked in the big factories, reading and lecturing without benefit of a sound system. Their voices were strong and their diction perfect.

They were paid 25 cents per week by each worker. As many as four hundred workers contributed, so the lector was among the highest-paid employees in the cigar industry. In the era when a first-rate cigar worker made $6 a week, the lectors could make as much as $100, a princely sum in those days.

Lectors usually read the *Tampa Tribune* in the opening hours, which meant that they had to be up early to translate the news to Spanish. Many liked to read from two different types of books. The first literary reading would be from the classics: Cervantes, Hugo, Shakespeare, or Molière. The second would be a popular dime novel. The workers voted on what popular novel was to be read. Differences of opinion sometimes turned violent (p. 21), but the dime novel was always the favorite reading. In the absence of radio and TV, they were the equivalent of our daytime soap operas.

Over the years, the cigar makers were transformed into the best-educated workforce in the world. Since the lectors were their teachers, the workers looked to them for leadership. In time, the lectors also read from political tracts, which were often of a socialistic nature, and argued for workers' rights. They supported unionization, better working hours, higher wages, medical benefits, and pension funds.

In the ensuing bloody struggle, the lectors helped the workers formulate their battle plans. The end was predictable. Ultimately, the owners banned the lectors from reading in the factories. The unions retaliated. The Big Strike of 1931 lasted ten months and almost wrecked the industry.

While they lasted, the lectors were the rock 'n' roll stars of Ybor City. A lector commanded the dignity and respect due an intellect, and had all the charisma of a movie star. They were sought out, and their function more than legitimized their presence.

But lectors were not found just in the big factories, and they weren't all towering personalities. Wherever cigar workers gathered, they found someone to read to them. In doing research for my novel, I even found out that my old-maid aunt Lola had read to a small factory contingent of twenty workers. This was the first evidence I had unearthed about the role of women lectors.

In *The Lector in Winter* I wanted to convey several things. First was the importance that cigar workers attached to the readings. Then I sought to show the close quarters of a *chinchal,* or a small, house-based cooperative of a few workers. The *chinchals* came about because the cigar makers needed to work during spells of unemployment, or to make extra money to supplement their wages.

I was most anxious to convey the cold of a Tampa winter in a small, wooden structure. Most of us lived in wooden homes where the only heat was one cylindrical kerosene stove. These were modestly effective and dangerous. Water was always boiling atop the stove to neutralize the carbon monoxide of a kerosene fire. Many pots were blackened as workers bent to their task, failing to refill the pot.

Here, the lector reads from a dime novel, his scarf covering his precious throat, a fedora on his head, fingerless gloves and a topcoat protecting him. The workers are similarly well protected, and one drinks a huge cup of *café con leche* to keep warm. A woman in a red woolen head scarf helps to select the tobacco.

In spite of their apparent discomfort, I think the painting evokes the pleasure of working close together in confining quarters, warmed by a fire, and of being read to as the hours while away. There is something Dickensian about the scene.

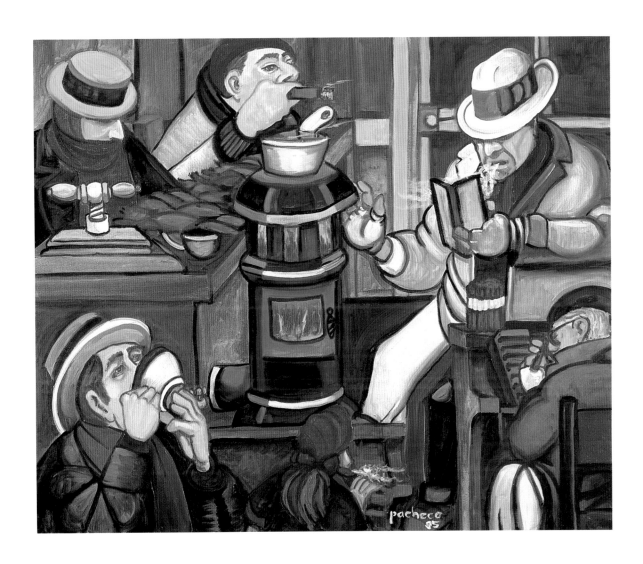

And God Created Tabaqueras

1995 · 40 X 30

Almost from the beginning, from the turn of the century onward, women were allowed to work side by side with the men in Ybor City's cigar factories. And why not? The cigar factories of Sevilla were populated mostly by women. The opening scenes of Bizet's *Carmen* show the women at work in the heat of the factory. Sevillanas were excellent cigar makers (*tabaqueras*), and many migrated to Cuba and Key West to form an important part of the growing industry's workforce.

Women were treated as equals in the cigar factories of Ybor City. This is well documented in the papers of that day, but in light of our current, revamped standards of equality, were they really treated as equals in every way? The answer is no, they were not. In interviewing many women cigar workers, I found that they all felt a complete equality with the men in the workplace. Almost as one they said, "We worked side by side with the men, the same hours, for the same pay. No favors were asked, and none given. In the factories, we were all the same."

But, if they became pregnant, women had to leave their positions and could not return until months after delivery, when the baby was weaned. And even then, they had to go to the end of the line of cigar workers awaiting employment. Some equality.

Men were allowed to make five large cigars (called *fumas*) for their own use each day. These were often used as barter for other services, or as a method of making extra money. Thus, a nonsmoker could profit more than his smoker neighbor. Women, however, were not granted this privilege, even if they had cigar-smoking husbands. Under no condition, in any factory, was a woman allowed to make the five extra cigars and keep them. Some equality.

The normal illnesses and stresses common to women, now recognized and acknowledged in our thinking, working society, were not recognized in the factories of old. Absences were not tolerated for PMS. Perhaps that is why we sold so much Lydia Pinkham in my father's La Economica drugstore.

And, during my interviews, when I broached the subject of a woman being promoted to *capataz* (foreman) to a 90-year-old former *tabaquera,* she laughed at the thought. She put her hand over her mouth, her eyes twinkled.

"A woman a *capataz*? Whatever for? What Latin man worth his salt would take orders or discipline from a woman? What woman would *want* to have that kind of work? She would have to be crazy." Thoughts of equality vanished.

My painting *And God Created Tabaqueras* is my tribute to these hardy women.

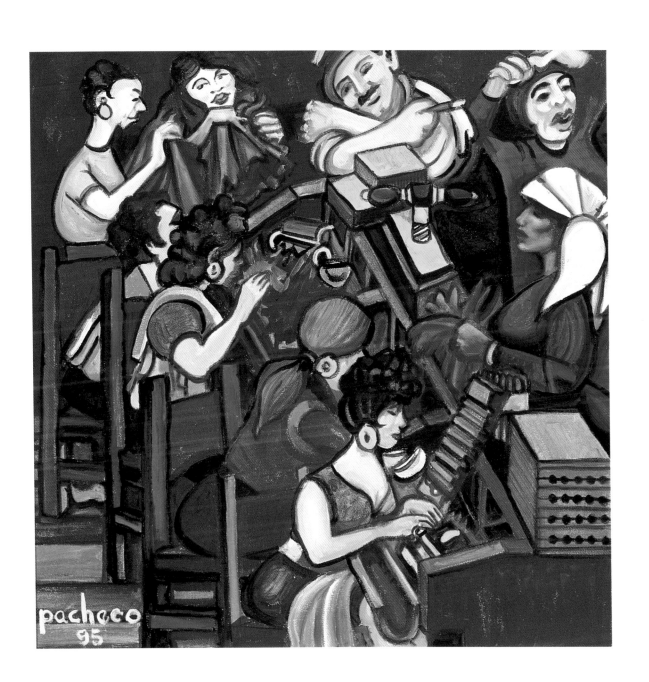

The Picnic

1995 · 50 x 60

This idyllic scene was drawn from my grandfather's description of such an event at the Regensberg Factory (El Reloj).

In the early days of cigar production, the workers' families lived in company houses nestled close by the factory. This allowed the wives to bring their children to have lunch with their husbands in the shade of the factory.

When the husbands returned to work in the afternoon, the wives would stay to listen to the lector read the *novela,* or dime novel. Since it was a reading of one chapter per day, the picnic became a daily event.

In the painting I focused on the women, their children, the food, and the feeling of camaraderie and happy repose of the families of cigar workers. The side of the Regensberg Factory still exists, but now an ugly asphalt parking lot has replaced the grass, and no warm familial picnics are held. More is the pity.

The scene is complete with the ever-present argumentative Latin males in the background, and a gallant, love-stricken old man presenting a young, beautiful mother with flowers. Inside the factory, the lector has begun his reading, and the men bend to their task. In keeping with my obligation to do corners well, I painted my wife, Luisita, listening avidly while our young daughter, Tina, sleeps.

The canvas is large (50 x 60) so as to accommodate the many figures and the detail of the food. As in most paintings I do, I introduced the richness of different shades of red and contrasting greens. This painting is one of happiness, and it may come as no surprise that of all those in the book I had the most fun painting it.

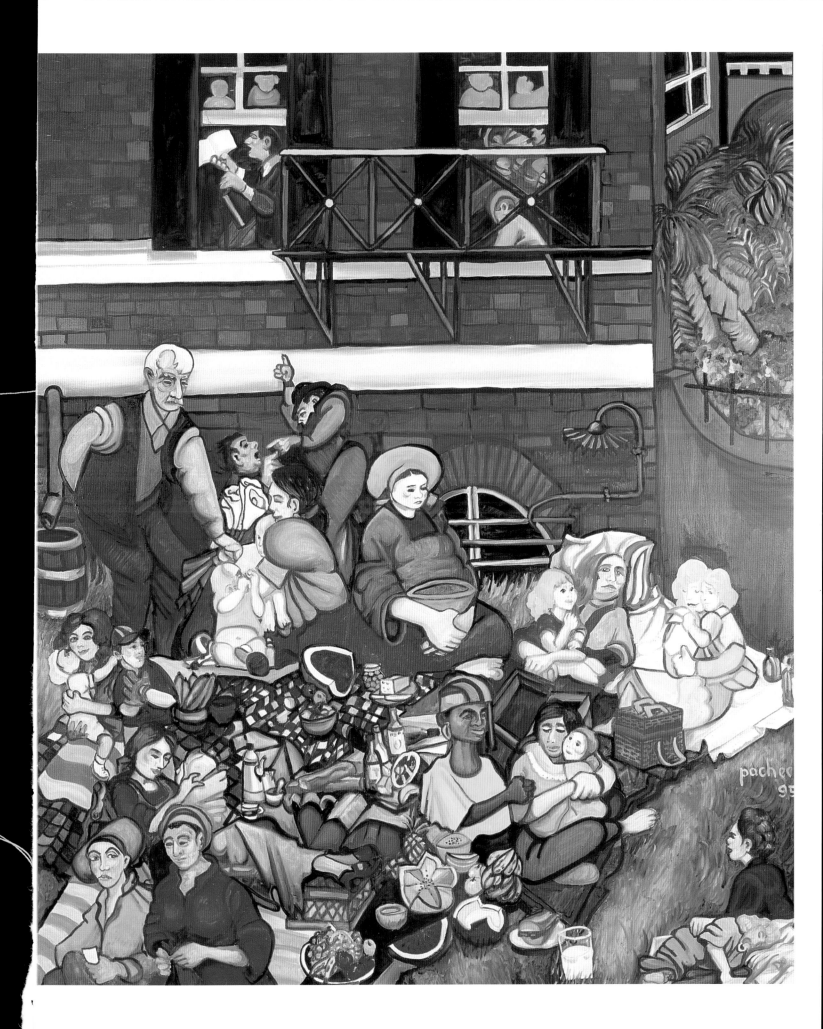

The Aged Lector: Don Victoriano Manteiga

1983 · 36 x 36

My involvement with recording the history of Ybor City began in 1980 with a visit to the most famous of all lectors, Don Victoriano Manteiga. The eighty-year-old lector was shrunken and bent. Advanced arthritis had twisted and curved his vertebrae, and his clothes hung loosely on his frame.

Don Victoriano had been a tall man of excellent posture, and was considered one of the best-dressed men in Ybor City. His bearing was that of a dignified gentleman of serious purpose. He was the living example of an intellectual.

My exposure to this famous man was initially to serve him coffee at the Columbia Café when I worked there as a teenager. Then, during World War II, he moved into an apartment we had for rent on the second floor of our family home. Here I was able to converse with him about a variety of subjects. I was bowled over. It was as if Albert Einstein had moved into my house.

In 1980 I took my wife, Luisita, to meet him, and she took the photographs from which I would paint his portrait. Also, I wanted to hear about the Big Strike, and other stories of the lectors' long, continuous fights against injustice.

Don Victoriano began slowly, speaking in a low voice, pronouncing his words precisely; as he progressed he grew stronger and his voice grew louder. The years seemed to drop off, a fire came into his eyes, and as he relived the years of bitter battle, he was no longer the aged lector, but the great and legendary El Lector, Don Victoriano Manteiga.

When it seemed that his voice had been stilled by the owners' banning of the lectors, Don Victoriano took his translations and his strong political views and began a newspaper, *La Gaceta*. As the sun was setting, and we sat in his offices at *La Gaceta,* Don Victoriano told us the story of establishing the nation's only trilingual newspaper.

As a kid in my grandfather's consulate, I remember reading both *La Gaceta* and its rival, *La Traducción-Prensa.* Eventually, only *La Gaceta* survived, and it is still the nation's only trilingual newspaper.

This portrait was named the best of the Tampa Museum of Art's "Ybor City Revisited" exhibit of 1994.

The references to earlier art works are most evident in Pacheco's portrait of Victoriano Manteiga, The Aged Lector. *This also happens to be a totally inspired painting that is far above the level of the other works in the show.*

Manteiga's strong face is divided into a treacherous map of land mines. The points of his color slash down into a shirt rippling with expressive ridges. His hands seem to be roughly whittled from the toughest oak.

You find yourself in the presence of an awesome personality, one that you won't easily forget. By now, you'll know the difference: This particular painting is not folk art. It is fine art.

JOANNE MILANI, *Tampa Tribune*

This review struck me as odd, for it was never anyone's favorite painting. It was Milani's feeling, however, that this was because I had revealed my heart so fully and had dug so deeply into Don Victoriano's essence that the portrait bothered viewers. I was happy to meet a critic of such perspicacity. I did paint this portrait with my heart, and I thought I cut through the icy front of the last remaining intellect of Ybor City, Don Victoriano Manteiga, and in some way got to the soul of this complex and brilliant man.

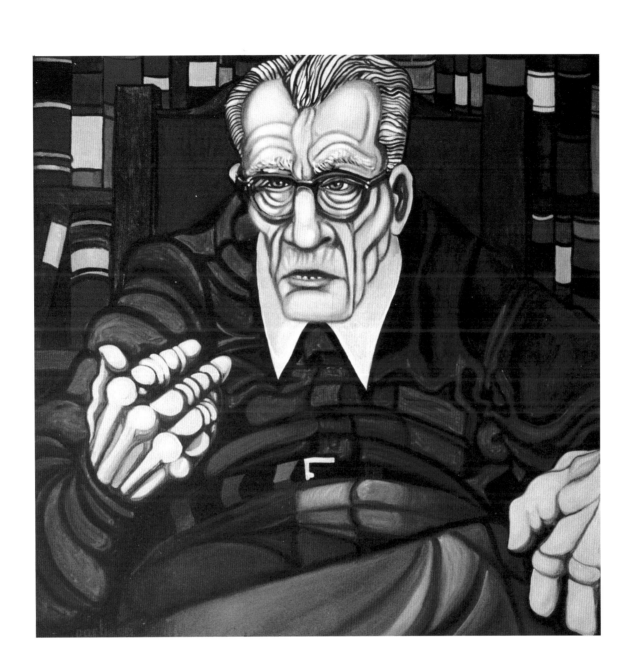

Roland Manteiga, Editor and Publisher

1995 · 36 x 60

When it became apparent that Don Victoriano Manteiga was failing and that a successor would have to be found if his newspaper, *La Gaceta,* were to survive, few Ybor City citizens felt that his son could fill his shoes. This, of course, is not unusual. Great men do not usually produce great sons.

Roland Manteiga was a boy growing up in the shadow of a giant. His early years were typical of every boy growing up in Depression Ybor City. As he came into manhood, Roland did not display signs of following the great lector's intellectual lead. But he was a handsome man, and a very hard worker at *La Gaceta.*

World War II saw Roland into the infantry; he was sent to the Pacific theater, where he fought with distinction at Bougainville and in the Philippines campaign. He was wounded and suffered from many tropical diseases. After a tough four years, Roland returned to Ybor City and reported for work at *La Gaceta.*

Roland did back-breaking work in the circulation department, and was also closely involved with every other department. He learned how to run the newspaper, and by the time of Don Victoriano's death in 1982, Roland was well qualified to take over. However, he did lack experience in writing and editorializing. The city waited to see what he would do with the paper.

Ybor City was dying in the eighties. The misguided urban renewal of the 1960s and '70s had emptied the city. Block after block of residential homes were destroyed, leaving grassy stretches. The community was rapidly becoming an empty vessel.

Of my generation, the second generation of immigrants, many returned from the war and took advantage of the G.I. Bill to get college educations and move on. The lawyers, doctors, bankers, dentists, stockbrokers, and businessmen now moved away from Ybor City. They relocated to Davis Island and the outlying suburbs. Ybor City was a virtual ghost town.

One voice remained to remind us that Ybor City was alive, that it was not moribund, that the memory of our fathers and what they had accomplished was being written about, and that our passage through time was being recorded. That voice was *La Gaceta,* and the man who kept that voice alive was Roland Manteiga.

Roland had hit upon two ways to make a subscription to this small newspaper indispensable to all those of the second generation. First, he discovered an amazing collection of old photographs. He began by printing one large photo of Ybor City history on each front page.

The next and most important feature was a full page of local news and editorial commentary by Roland Manteiga called "As I Heard It." It became a political watchtower. It was available to anyone for announcing political or private events.

Roland Manteiga's column became the way we kept up with each other. We who lived away from Tampa considered it essential for keeping up with our friends. Whether you were a screenwriter in Los Angeles, a boxing manager in Houston, a colonel in Vietnam, or a S.A.C. pilot in Guam, you subscribed to *La Gaceta* to see what new craziness was going on in Ybor City.

This portrait of Roland Manteiga was painted in 1995 as part of the Hispanic of the Year Award. I had been chosen by Roland to be his presenter, but at the last moment I had a television commitment which precluded my being there. I decided to honor him by painting this rather formal portrait.

Roland usually dresses in white suits, in the style of Mark Twain. But I did not want to paint a large portrait that would end up looking like a bottle of milk of magnesia, so I chose the honorable way out: I painted him in the style of John Singer Sargent, using the portrait technique common at the turn of the century. To heighten the dramatic impact, I chose to paint him standing in a half light, with only half of his face visible.

This prompted Roland Manteiga, a shy and reluctant speaker, to open his brief acceptance speech with a rare jibe: "I have not yet paid Dr. Pacheco for his fine portrait, but he assures me that when I do, he will paint the other half of my face."

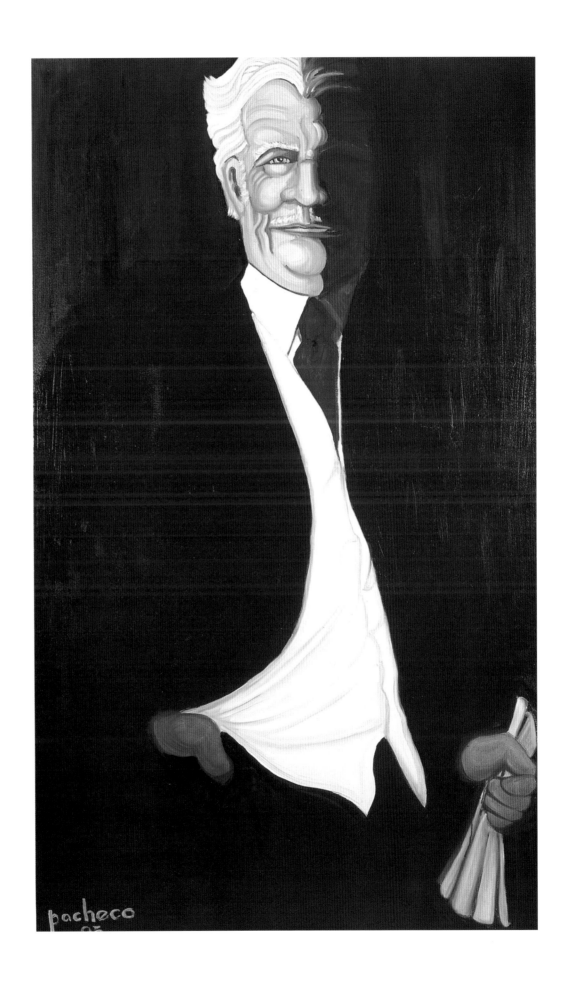

A Matter of Words

1995 · 30 x 40

In 1903 the *Tampa Tribune* told of a fascinating turn of events. In all of my research and reading on the role of lectors, I had never run across such an unusual example of literature's impact on the masses.

Two cigar makers worked side by side in a factory for years and were fast friends. One was a Mexican, the other a Spaniard. In time the Mexican married an American lady who spoke Spanish and also worked in the same factory.

When the time came for the lector to announce his selection for the month's reading, the workers stopped their work to listen. He announced that he would be reading Emile Zola's *Germinal.*

The Mexican objected immediately. He would not have filth read to his wife, who would have to sit in mixed company and bear the obscenities of that French novel. (Zola's novels were known to go into the kind of graphic detail that should not be heard in public.)

The Spaniard disagreed. Why should the men be deprived of hearing the work of a great novelist because he described acts that each adult there performed? The other married men present reacted violently, and an argument started which sputtered and flickered during the tense week.

"Tell the women to leave the room when the lector reads the Zola novel," the bachelors said with what they felt was reason.

"What, and miss an hour of work?" the married men answered.

The Spaniard and the Mexican had eaten supper together at the Fourth of July Café since they were bachelors, and they continued to do so after the Mexican took his bride. But on this night, both men appeared at the café in an agitated state, and both were armed. The argument at the factory had reached a climax. Harsh words had been exchanged.

According to the *Tampa Tribune,* violence broke out as soon as the two men spotted each other. The Spaniard was armed with two revolvers, and the Mexican carried one six-shooter Colt.

When the smoke cleared, the Mexican lay on the floor with four holes in his chest. The Spaniard was down with one bullet in his. Seeing that the Mexican still lived, the Spaniard went to the kitchen and found a large butcher knife, which he plunged into the Mexican's heart.

In all my years of reading and watching the effects of literature, I could not recall any similarly homicidal scenarios. Further research on the subject of literature's effects yielded other surprising episodes. A 1901 *Tampa Morning Tribune* netted an article under the headline, "'Ere's a Pretty Howdy Do." The subheading tells the story: "Sex Against Sex—Men Want Book Read, and Women Object. So Both Go On Strike." The book in question, by Paul de Koche, was called *El Cornudo,* or *The Cuckold.* How it was settled is not recorded.

A sidebar to my investigations on the fractious nature of the Latin cigar makers of Ybor City reveals a hilarious example of maximum querulousness. Vincente Martinez Ybor built a factory and hired an entire crew from out of town, including his *capataz* (foreman); before they set foot inside the factory, they had a disagreement with the owner and promptly went on strike! Now that must be a world record for labor contentiousness.

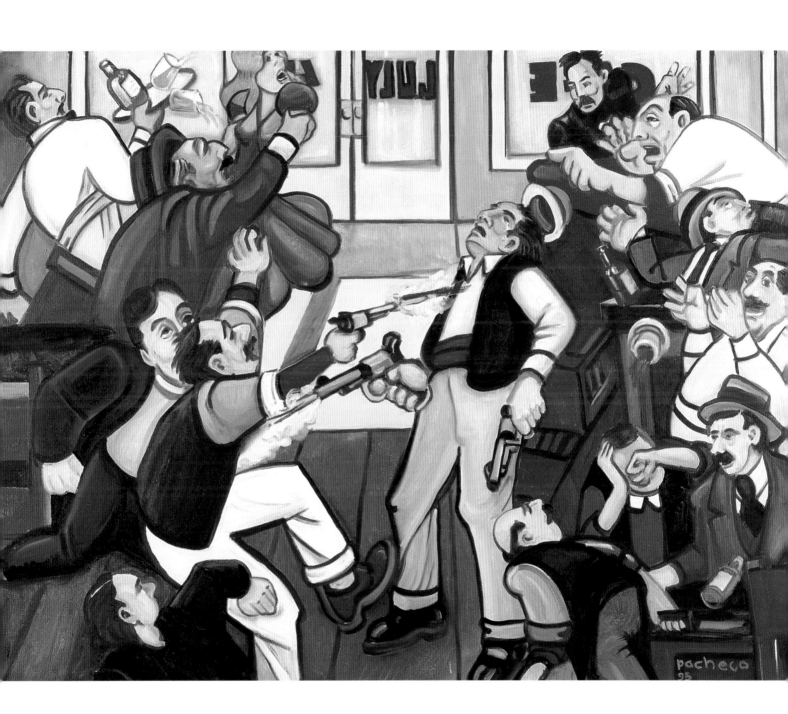

The May Day Parade

1994 · 36 X 30

By the mid-1930s the cigar workers were turning to socialism and its more malignant offshoot, communism, as a viable alternative to democracy, which seemed to be failing.

Everyone in the cigar industry followed the Spanish Civil War very closely, since almost every Spaniard still had family living in the mother country. Those who supported the government were called Loyalists, while the rebels were led by General Francisco Franco and were called Nationalists.

As the war escalated into a brutal, bloody punching match and atrocity piled on atrocity, the world took sides. General Franco was a Fascist, so he found ready aid from Hitler and Mussolini. They were eager to test their arms and new ideas of warfare in actual combat. The Loyalists represented the democratic world, but they found that the war-weary democratic countries of England, France, and the United States were long on rhetoric and short on supplies.

Seizing the opportunity presented by this void of material support, Joseph Stalin offered his help. With his stream of military supplies came the price: allegiance to Communism. The Spanish Civil War became the testing grounds for two polarized, political worlds. In time, of course, the Fascists won out against the Reds.

In Tampa the Communists fought a struggle to be recognized but met with a stone wall of indifference. They needed a dramatic breakthrough to call attention to their cause and swing public opinion to their side. They had been denied the right to celebrate May Day, the Communist Party's Fourth of July, with a parade. The Tampa government would not allow a Communist demonstration on May Day.

Then the Communists caught a break. The moment they had prayed for came in the most unexpected fashion. A horrible event galvanized the world against Franco and opened the way for public acceptance of Communism.

The Condor Legion, a contingent of Nazi flyers under the brilliant Colonel Wolfram von Richthofen, was ordered to carry out a scientific experiment. They were to bomb a town. The objective was to evaluate the psychological impact of unreasonable slaughter of an in-nocent population. How would it affect the military? How would the populace respond?

The Fokker tri-motor bombers caught the unsuspecting population of Guernica on a market day. It was April 26, 1937, and the day would be well remembered for its senseless slaughter. Picasso would commemorate it in one of his most famous paintings, *Guernica*. When it was pointed out that it was the only work he had not signed, he said, "It is signed in the blood of Spain." *Guernica* proved to be one of the strongest pieces of propaganda art ever produced. When Picasso showed it to the German ambassador, the Nazi was shocked. He could only stammer, "You did this?"

Picasso fixed him with his large, steely black eyes and barked, "No, you did."

In Tampa the cigar workers moved with lightning speed and organized a committee, led by Don Victoriano Manteiga, to petition the mayor to let them parade in the streets of Tampa to protest the atrocity. That it happened to fall on May Day did not seem to matter to anyone.

And so the May Day parade took place after all. The Tampa Electric Company volunteered a few streetcars to carry the old and infirm, and children were let out of school to march. Red flags were waved and, arms locked together, the workers marched to City Hall. They sang the "Internationale" and "Bandera Roja" ("Red Flag"), and the parade grew as it approached City Hall, where Mayor R. E. L. Chancey addressed the assemblage. He was followed by a fiery speech in Spanish by Don Victoriano Manteiga. Many a young hothead tried to enlist in the International Brigades to fight in Spain on that emotional, highly charged day.

The political climate has changed many times since those heady days. The Reds were "in" during the Spanish Civil War, "out" during the Finnish War, "in" during World War II, and decidedly "out" since then.

This painting is a political liability. It can be shown in Tampa as depicting a historic event. It cannot be shown in Miami, where a million Cuban refugees will not tolerate the sight of a red flag.

Nonetheless, I wanted to record this unusual day. The placards protesting "No Pasarán" were abundant

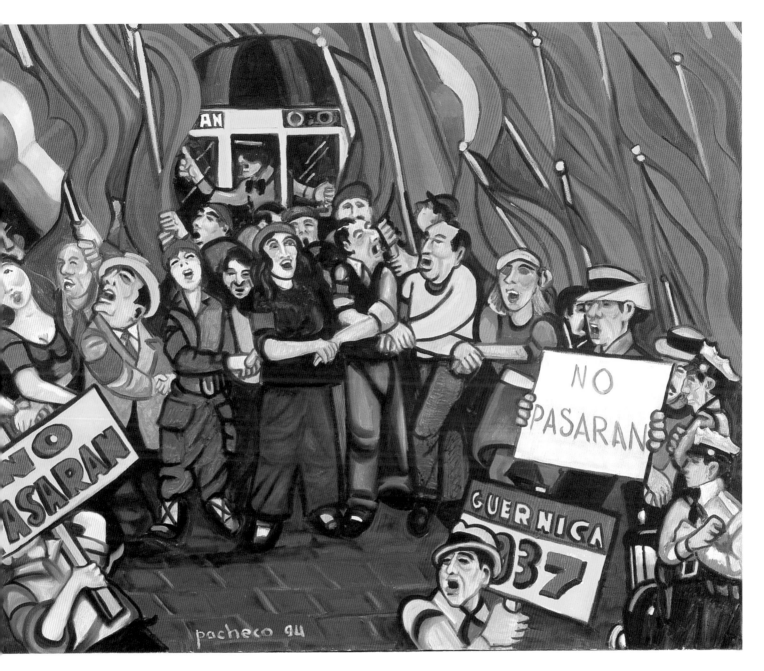

in the parade, bringing to mind the fiery woman leader La Pasionaria, who personified the dogged resistance of the besieged Madrileños, caught in the hell of the battle for Madrid. "They Shall Not Pass" was first used by General Pétain in his brave fight in Verdun in the First World War. La Pasionaria picked it up, and it became the Loyalist battle cry.

The streetcar was included in the painting because it came to represent the fractiousness of Ybor City residents. The battle started as soon as the trolleys pulled up. Who should ride? It was for the old and infirm, yes, but how old was "old"? How sick was "sick"?

As often happens when argumentative people get together, the problem was solved by an old rule: Might is Right. The strong rode, the aged and infirm waited by the side of the road. I felt I had to put in a trolley.

The thrust of the painting is the power of an outraged populace. The backdrop of red flags gives the painting a fiery quality, as if the people were stepping through the flames of Guernica to protest.

Green Hornet Buzz

1995 · 30 x 36

If there was one quality never ascribed to the austere publisher and editor of *La Gaceta,* it was a sense of humor. Don Victoriano Manteiga was not a light-hearted man. He was not amused by the eccentrics, by the jokers, by the storytellers of the streets, factories, and cafés of Ybor City.

How then can we account for the presence of a highly humorous column of scabrous gossip called "The Green Hornet," which appeared monthly in *La Gaceta?* In the days before the *National Enquirer,* few prominent people were written about in less than reverent tones. And, of all the people who represented ultra-conservatism, the seriousness of life, and the upholding of prudence and decorum, none stood above Don Victoriano Manteiga.

So why the Green Hornet column in *La Gaceta?* Why the scurrilous listing of the peccadilloes and embarrassments of the most prominent citizens—thinly veiled, of course, but recognizable nonetheless?

My painting depicts the attention given to the monthly appearance of "The Green Hornet." This is a scene I witnessed from the point of view of a sixteen-year-old waiter in the Columbia Café, the coffee shop at the Columbia Restaurant. It contains some prominent citizens, most of whom were targets of the Green Hornet's sting. The rest of the cast is comprised of employees at the Columbia Restaurant.

In the bottom row at mid-painting is Casimiro Hernandez, the restaurant's owner, who was known for falling asleep in mid-conversation. Here he has fallen asleep while reading "The Green Hornet," presumably after making sure he wasn't mentioned.

Next to him is Ybor City's most notorious pair, Dr. Jorge Trelles and the beautiful Conchita. Dr. Trelles was sure to be mentioned frequently, but he loved it. To the left of Conchita is the Grand Old Man of Tampa crime, Charlie Wall, otherwise known as the White Shadow.

Charlie Wall was from a prominent pioneer Tampa family. They were wealthy and carried big political clout. An admirable family, the Walls had produced military leaders, politicians, and scores of professional men. Charlie Wall was the black sheep, the rotten apple in the barrel. Worn down by his peccadilloes and brushes with the law, the family sent Charlie to Ybor City to put some order to the gambling, prostitution, and night life that was becoming an embarrassment to Tampa.

Charlie Wall built a home in the middle of Ybor City and brought order of a sort to the warring crime factions. He was a hero to us kids, for we regarded the dangerous figure as a Robin Hood. Except that he stole from the rich and kept it.

Moving up the side of the painting, we see the dwarf who served coffee at the Centro Asturiano for sixty years. Then we have two legendary café waiters, Bebi and Eddie, who worked for decades at the Columbia. Bebi eventually opened the Tropical Sandwich Shop, which eventually replaced the Columbia Café as a meeting place for all of Ybor City.

In the doorway to the *fonda* (restaurant) and kitchen stands the famous Pijuan, master chef, who scans the paper with Sarapico, his successor. Looking on is another legendary Columbia waiter, El Rey, the king, whose dignified manner and uncanny resemblance to Spain's King Al-fonso XIII kept him out of the Green Hornet's column.

Two streetcar conductors sip their coffee as Pete Scaglioni, the tough bartender, pours a drink. In the middle of the painting is the famous Ybor City confidence man Dr. José Luis Avellanal, the Dream Merchant, decked out as a lieutenant general of the Mexican Army. By his side is the ex-lector Pan-con-Chinches ("Bread-and-Bedbugs"), Ybor City's first displaced person.

No one ever confirmed who wrote "The Green Hornet." It was sharp, humorous, and it pricked many an inflated ego. In time it got to be a badge of honor to be named in its pages.

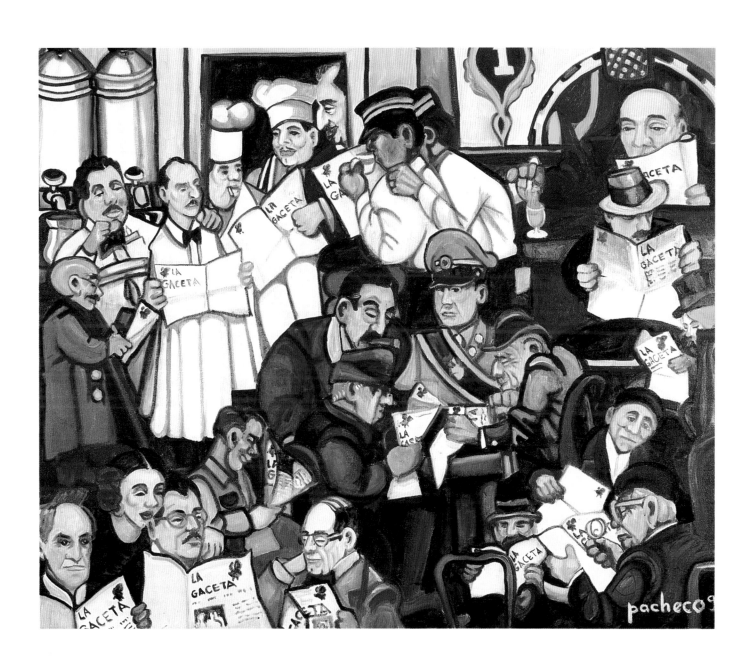

Bolita and the Law

1995 · 30 x 30

Most of Ybor City's trouble with the lawless came about because of bolita, the "other" big industry in Tampa. Bolita was the numbers racket, plain and simple. It was played by almost every family in Tampa. It offered a momentary lift out of the tough economic grind of hard times. The oral history of Ybor City citizens is sprinkled with the magic of the moment when they "hit the number" and could suddenly realize a dream. For some it meant a down payment on a house, for others the purchase of their first car. For some families (like mine), it meant two months at the beach at Pass-a-Grille.

In tough times bolita gave everyone a small ray of hope, a reason to expect things to get better. It was uplifting. It was also illegal. Therein lay the trouble.

At the time of the bolita wars, several gangs were contending for control. Cubans, Spaniards, Jews, and Sicilians slugged it out on the red-brick streets of Tampa, and the *Tribune* ran stories of assassinations that always seemed to go unsolved.

Eventually, Charlie Wall and a loose coalition of the surviving bosses settled into an uneasy truce with each other and the police and ran the bolita business, netting huge profits in the process. (A famous criminologist from the University of Florida, Dr. John Vetter, posits: "Organized crime cannot exist without the *knowledge* and *consent* of the police.")

Bolita ran on its quiet way because the bolita barons paid off the officials. At one point a crime-busting series in the *Tampa Tribune* ran a story claiming that of the hundreds of known bolita peddlers working in Ybor, only *six* were not protected from arrest.

Like most businesses, bolita had a sales force whose members each had their own territory. The Columbia Café was the domain of a short, fat, nervous Italian, who for our purposes will be called Chicken Cacciatore. He was a sweet, mild-mannered family man who was temperamentally not cut out for a life of crime.

In the painting, Cacciatore is selling a Tampa policeman a bolita number. Everyone behind him suggests a number; even Ralph the janitor has an opinion. Cacciatore is not happy to be writing a number for the cop.

Chicken Cacciatore was a victim of coming to the business before the revolutionary advent of flash paper, which incinerates rapidly and leaves no ashes. Since Cacciatore lived in dread of being arrested, the sight of an unknown cop in the café would send him dashing for the bathroom to eat his slips. We all expected that one day Cacciatore would be dragged off to the Trelles Clinic for treatment of an intestinal obstruction of—what else? A bolita-slip fur ball.

Although I have done many paintings of street assassinations, the throwing of the bolita bag, and other scenes highlighting bolita activity, I felt this comic scene of Chicken Cacciatore's distress at having to sell a number to a cop in full view of the Columbia Café best exemplified the era of bolita.

Bolita came to its end in the usual way. Politicians recognized its profit potential and simply took over the whole operation by making bolita legal. They called it lotto. But the citizens of Ybor City knew that whatever it was called, it was still just bolita.

The painting *Bolita and the Law* captures the permissiveness of the law and the complicity of Ybor City citizens in the bolita business. It was illegal, but everybody played it. It only cost a nickel, and that seemed a small price to pay for a dream.

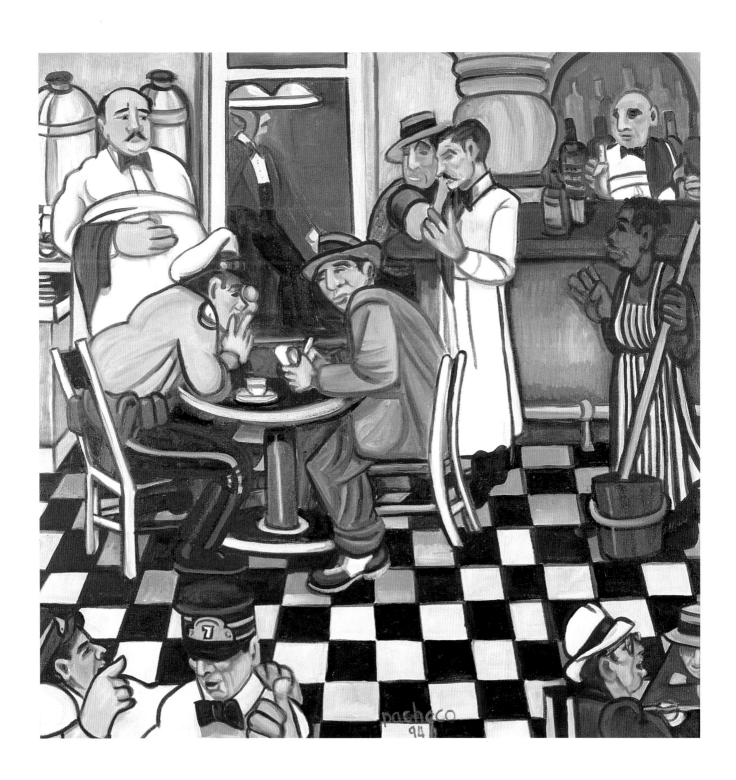

Surgery by the Book

1986 · 30 X 22

A great part of my medical education came at the hands of the brilliant Dr. Jorge Trelles and his impressive other half, the beautiful Conchita Trelles, nurse, midwife, anesthetist, and ex-courtesan.

The Trelles Clinic was a small, independently run, socialized medical clinic. The kind-hearted Dr. Trelles ran the clinic almost single-handedly, and for a small weekly stipend from each member, he provided all medical services. As a young student, I was delighted when he allowed me to observe him in surgery, and later to assist.

Dr. Trelles was especially gifted as a surgeon, and he operated on all types of cases every day. One of his rules was that he would not start a case without re-reading the corresponding medical text, even if he had just performed a similar operation the previous day. In this way he kept the details fresh and did not make silly mistakes. I even saw him send for the book in the middle of surgery to make sure of the steps he should take.

In paying my respects to him and the other excellent surgeons of Ybor City's socialized medical clinics, I decided to do a painting entitled *Surgery by the Book.*

If Dr. Trelles's assistants stood in awe of his skill, they were in open-mouthed admiration of the beauty of the anesthetist, Conchita Trelles. Possessed of stunningly dark eyes, black as olives, and an imposing figure, she was a sight to behold in surgery. The surgical mask made her eyes seem all the more mysterious. The real distraction, however, came as Conchita nestled the patient's head in her lap so as to administer the anesthetic. Her skirts were tight, and she could only hold the head in her lap by hiking her skirts to mid-thigh. Conchita had world-caliber legs just this side of Cyd Charisse perfection. Trelles, an unabashed ladies' man, found all of this very funny and especially enjoyed catching me ogling her perfect legs.

This painting captures the charm of those long afternoons in surgery with Dr. Trelles and Conchita.

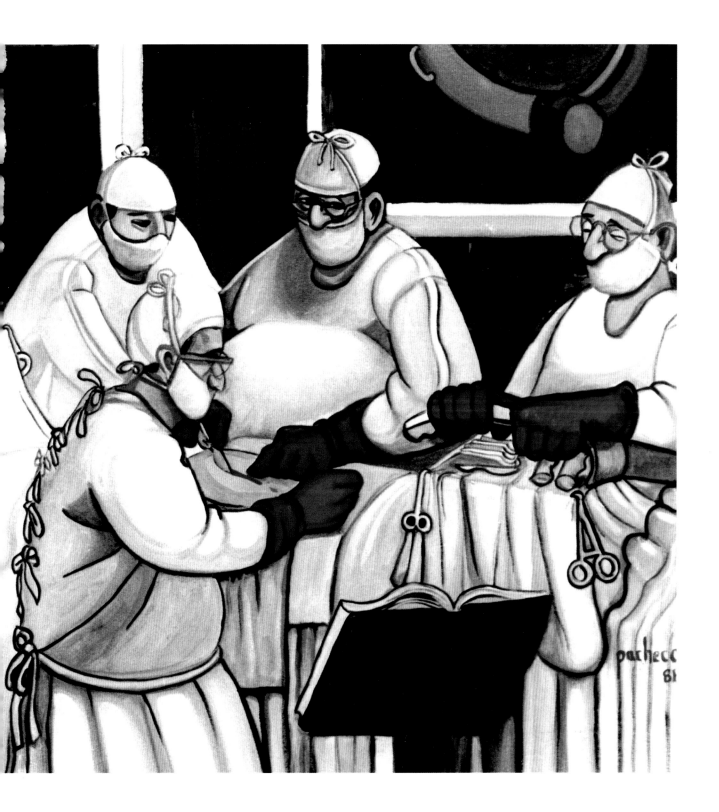

Sicilian Immigrant: Reinforcements Arrive

1995 · 28 X 22

When we said "Italian" in Ybor City, we actually meant "Sicilian," but time blurred the distinction and "Italian" prevailed. In the grim portrait *Sicilian Immigrant: Reinforcements Arrive,* the impression we had of the hard-faced Sicilians is reflected.

Because they were "different" from us, the Spanish-speaking immigrants, the Italians were consigned to the outer edges of Ybor City. Most had come from the peasant class and were considered expert in agriculture. For a time they were excluded from the cigar factories and from Ybor City's social life. The consensus was, moreover, that they were a violent people. The fame of the Black Hand spread from New York, Chicago, and New Orleans. The average Hispanic was happy to give them a wide berth.

The subtitle of this portrait says it all: "Has he come to share his agricultural expertise with his American relatives, or is he here to settle a centuries-old blood feud in expert manner?"

The Sicilians who came to Tampa were, at first, the butt of jokes born of ignorance. Sicilians were close-mouthed (unable to speak Spanish or English), clannish, and the dark cloud of the Black Hand and the creed of Omerta hung over them.

They had a lot to overcome, but overcome they did. Grossly underevaluating their industry, intelligence, and drive, the Hispanics watched in amazement as the Sicilians came to dominate the marketplace. They quickly surmounted the language barrier by learning Spanish. No Spaniard, Cuban, or Puerto Rican ever learned Italian as fast as the Italians learned Spanish. The Sicilians adopted our ways and food. Ybor City abounded with excellent Spanish eateries, but I cannot remember one exclusively Italian restaurant. Not one. While the Hispanics languished in the easy life of the cafés and social clubs, the Sicilians, by dint of hard work and intelligence, quietly took over most other aspects of Ybor City life.

A cursory look at the families I knew as a boy in Ybor City reveals the Italians' many areas of accomplishment. They began by dominating the produce business, with the Geracis, Valentis, and Guillardos in the dairies. Then there were the Allesis in the bakeries, the Matassinis and Aglianos in the fisheries, the Grimaldis in banking, and the most beloved of all politicians, Mayor Nick Nuccio. In medicine the Italians produced a hero of national fame, Dr. Frank Adamo, who was the hero of the Bataan Death March and appeared on the cover of *Life* magazine. Lawyers and judges like the Spicolas and Raganos and plenty more of their ilk abound. Finally, the winners of the bolita wars turned out to be the Italians. While this might not be viewed as an accomplishment in the rest of the state, in Ybor City it was.

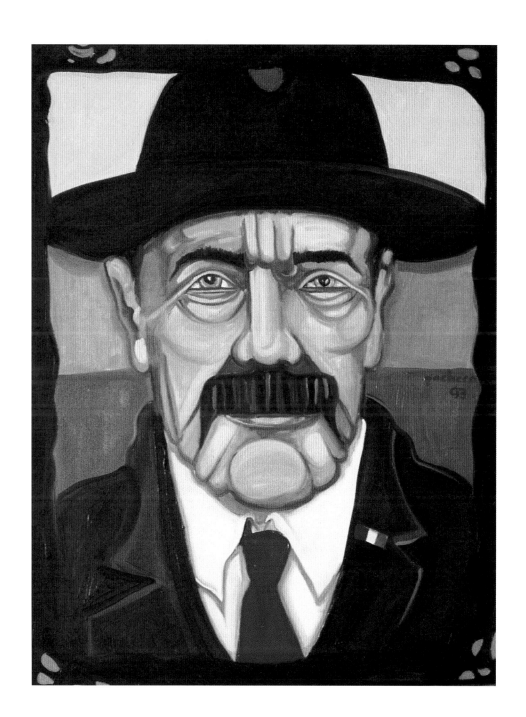

The King of the Italian Club

1993 · 30 X 25

The King of the Italian Club is done with a great deal of humor. I would be less than accurate if I did not relate that the Hispanics of the 1930s viewed the Italians with a bemused eye. They had yet to understand that this was an energetic and intelligent people, descendants of the world-conquering Roman Empire and offspring of the fiery patriot Garibaldi.

As regards our prejudiced notions about Italians, I can only attribute them to three causes. First was the Italians' humble beginnings, relegated as they were to goat farms and vegetable patches in the outlying reaches of Ybor City.

Second was the contempt that we felt for the bombastic Mussolini, whose string of embarrassing defeats in Ethiopia, Libya, Guadalajara, Spain, Albania, and Greece somehow cast all Italians as a race pathetically unprepared to fight for their country. Of course, the record of brave Italian-Americans who fought in the Second World War later altered that fundamental misconception.

We were also influenced by Hollywood and its stereotypes. Henry Armetta was the foremost clown, and we all thought Chico Marx was Italian, though he wasn't—he was Jewish.

Over the years prejudice waned as the Italians and Hispanics of Ybor City became neighbors, business associates, and friends. My paintings of Italians constitute my tribute to the many prominent Sicilians who helped build Ybor City.

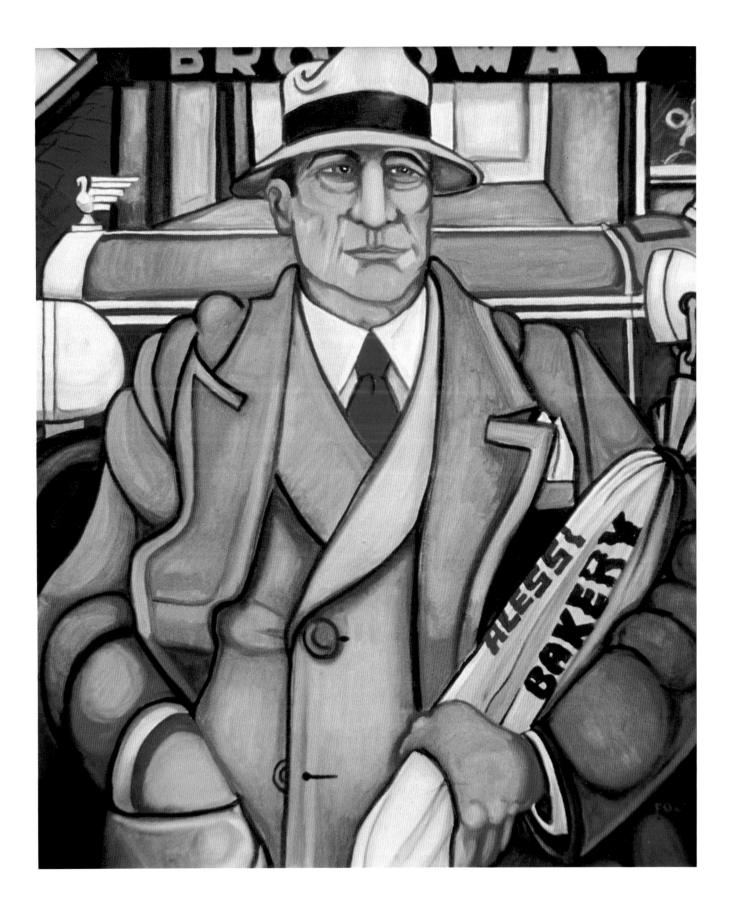

Puttin' on the Ritz

1993 · 72 x 36

Dr. José Luis Avellanal easily outdistanced anyone I ever met for the brilliance and originality of his many lives and careers. No one in Tampa's history has even approached Dr. Avellanal's height of notoriety and self-deluded folly.

The son of a long-suffering physician who tried every disciplinary measure conceivable to curb his son's rampant energies, José did manage to finish college and graduate as an attorney. His perseverance, however, was largely attributable to his father's bribe: the promise of $200 a month for life and a Dodge roadster if he finished.

As soon as José received his diploma, he ran home to take possession of the coveted Dodge roadster. Instead, he found a stern-faced father who informed him that since he was now a professional, he could buy his own car and support himself.

José was so outraged by his father's duplicity and so disillusioned with life that he repaired to his room at El Pasaje Hotel, where he wrote a eight-page suicide note and then tried to shoot himself. Both he and the note survived. The note, now in the Avellanal Collection of the University of South Florida History Department, is a masterpiece of pomposity, self-delusion, and self-pity.

In time, and over the space of a lifetime of struggle, Avellanal presented himself to the people of Ybor as a lawyer, realtor, gynecologist, plastic surgeon, Baptist minister, college professor, and as the president of his own Southern University. Over the years he also managed, under the auspices of Cuba's President Batista, to create the Legion of Honor of the Republic of Cuba, which he then conferred on gullible officials. In his greatest coup, he convinced the president of Mexico that he was a renowned expert on postsurgical recovery of cancer cases and obtained a lieutenant general commission to run an abandoned army hospital.

During Avellanal's early years he developed an eye and an absolute need for the company of young ladies. This did not abate throughout his long life, and he was considered a flashy man about town. His suite at El Pasaje Hotel was considered a den of iniquity to which he lured young ladies to listen to him read and teach philosophy. Most young girls of Ybor City were warned to stay clear of the young Don Juan.

I have done an entire suite of paintings on the theme of the Dream Merchant and Confidence Man, José Avellanal. For inclusion here I have chosen the two that best exemplify him as the elegant young man-about-town.

This first black-and-white study is in the Art Deco style of the thirties. Formal attire was always worn to the cabarets in the social clubs. Dr. Avellanal was a dandy in dress, and he always chose the most elegant of ladies to accompany him.

The reason I decided to forego color was that I wanted the painting to have the feeling of a 1930s movie. With the country in the Depression, the prevailing colors were black, gray, brown, and olive drab, and movies in color were not common until the '40s. The moguls of Hollywood decided that people needed to be cheered up with visions of impossibly beautiful people in gorgeous clothes.

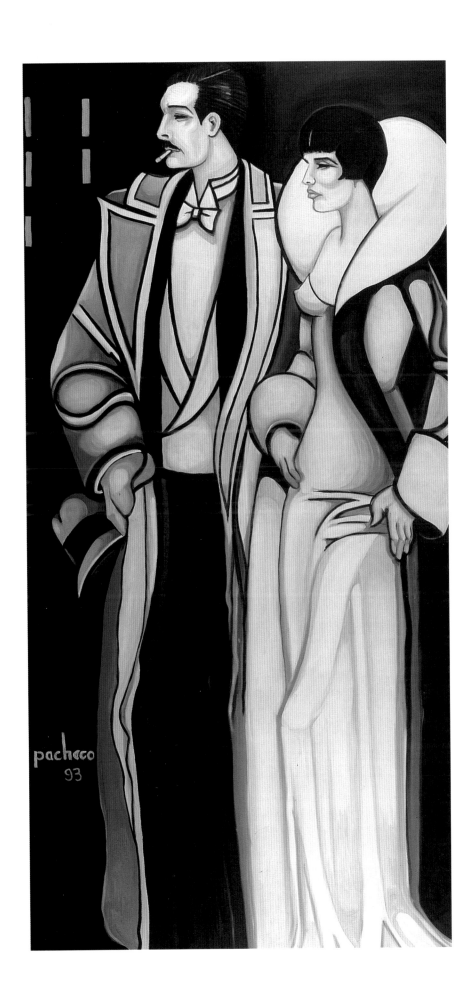

Flying Down to Rio

1993 · 48 x 60

This painting of José Luis Avellanal is a romp. It is based on the movie *Flying Down to Rio,* starring the beautiful Dolores del Rio and Fred Astaire, a Busby Berkeley masterpiece featuring airplanes and chorines. Aviation was the hot item in the thirties, so Hollywood capitalized by putting beautiful faces in glitzy pilots' helmets. The lady in this painting was inspired by Katharine Hepburn, who played a mannish aviatrix in another popular film, *Christopher Strong.*

The painting is created from a series of loose circles which come together to form one joyous motion. The backdrop is a cubist rendering of modernist buildings with their squared tiles. The focus here is on design, and I tried to capture the joy of a ladies' man out on a Saturday night with an unusual and gorgeous girl on his arm.

Dr. José Avellanal set a record for false identities (see preceding painting), and for avoiding incarceration. He lived until his late seventies and died trying to prove that a person could reach the age of 100 simply by eating twenty-five oranges per day. For this he earned the everlasting gratitude of the Florida Citrus Commission.

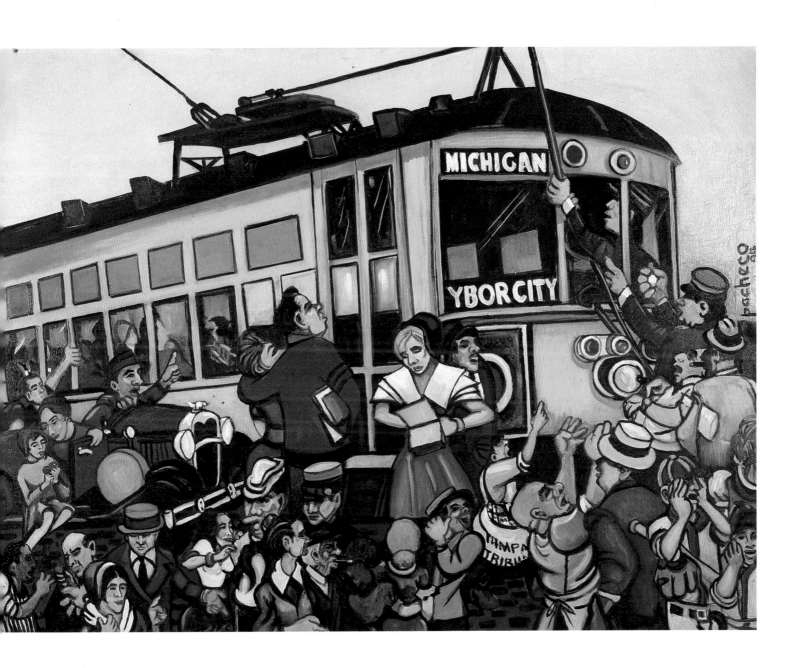

Segregation and the Purple Heart

1994 · 40 X 30

This painting depicts a real-life incident which occurred during the war. I was in high school in 1944, when the war was at its height. All of my friends had already enlisted, and as I was too young to join, I did the next best thing. I read all I could in *Time* and *Life* about the war, and kept up a lively correspondence with my pals. I was possessed with patriotic fervor and full of notions about liberty and equality which I had gleaned from studying the Constitution and the Bill of Rights. Although I was a southerner through and through, I could not reconcile what we were fighting for with the shameful way we treated African-Americans. I was an early veteran of American civil rights struggles.

All of these factors came together one afternoon when I caught a streetcar which was empty except for a black soldier sitting in the back of the car in the Colored Only section. Wounded, he had crutches and wore a Purple Heart on his be-ribboned chest. He looked forlorn and alone there, and something clicked in the back of my head. The Don Quixote factor kicked in. As familiar as anyone with the beauty of the futile gesture, I marched to the back of the trolley to sit with him. By doing this I hoped to show him that there were those of us who did not willingly contribute to the injustices he was forced to suffer.

Well, the thought was good, but the reality of life in the South overwhelmed my good intentions. Immediately the streetcar conductor stopped the trolley and came back to where I was sitting. With a jerk of the thumb he motioned me to my seat.

"Sit where you belong or get off!"

I looked at the wounded soldier, and he gave me a sympathetic look that seemed to say, "You poor sap. Get back up there where you belong." I hesitated for a moment and his look changed. It clearly said, "Go on, boy, I had all the trouble I need in Europe. I don't need any more trouble at home. Go on, get in your own seat."

For this painting I used a series of photographs of the inside of the Birney streetcars. The poster which reads "Loose Lips Sink Ships," and the Lucky Strike ad were from my own memory. The streetcar interiors were masterpieces of woodwork, and the clean, electrical scent of the trolleys was heavenly.

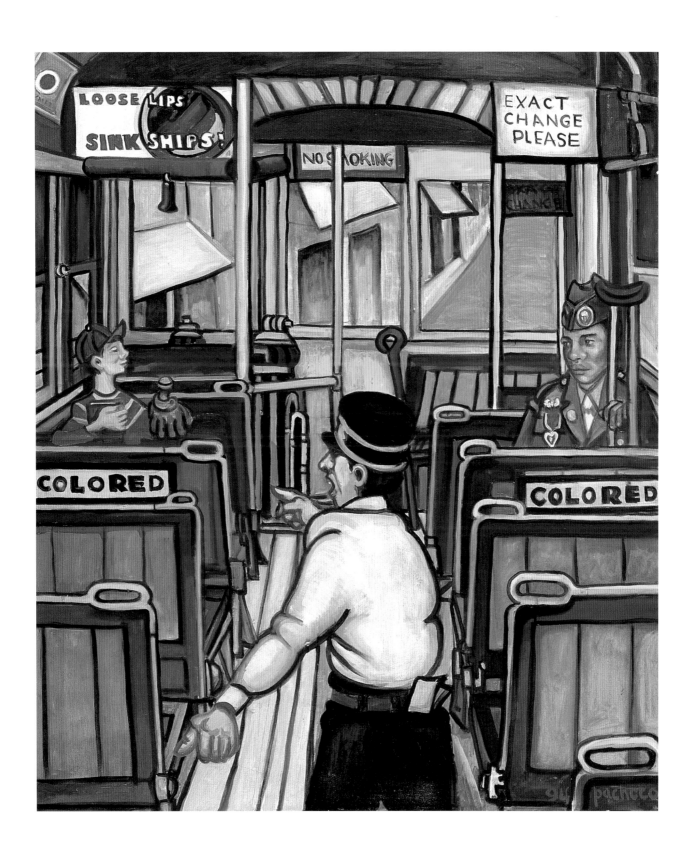

The Trolley and the Minaret

1995 · 40 X 30

This painting is of a 1935 scene wherein the Hillsborough football team waits to get on the trolley which will take them back to Seminole Heights. The scene takes place on Lafayette Street, which is now John F. Kennedy Drive, in front of the University of Tampa.

To add a touch of humor I painted a local football fan in his Model T, stopping to give the coach a few pointers on how to run the team. The boys in their simple football uniforms ignore him as they get ready to board the trolley. Emblazoned on the front of the streetcar is the familiar sign of the Work Projects Administration: W.P.A.

Visible in the upper right corner of the painting is a minaret of the old Tampa Bay Hotel, one of Tampa's most characteristic edifices. In 1915 the Atlantic Coastline Railroad Company gave the hotel to the city of Tampa in lieu of paying back taxes; in 1933 it became home to the University of Tampa. With its thirteen minarets and cupolas, the hotel was noted for its Moroccan architecture and was a favorite penny postcard scene.

What better way to evoke the Tampa of those years than by making use of the minarets, the red brick streets, distinctive lamp posts, and yellow streetcars that defined Tampa for so many visitors?

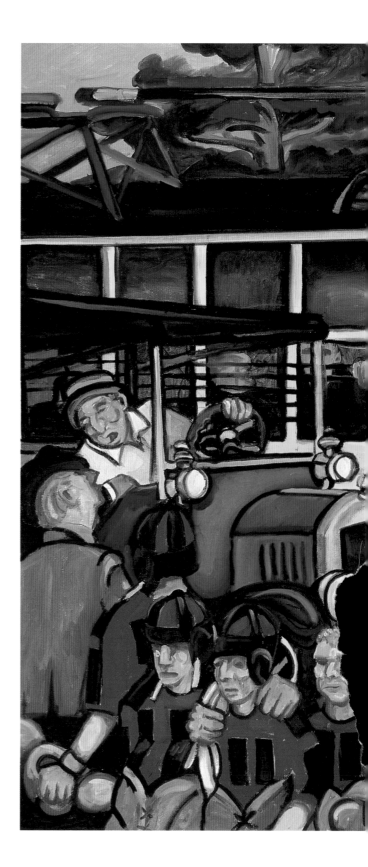

42

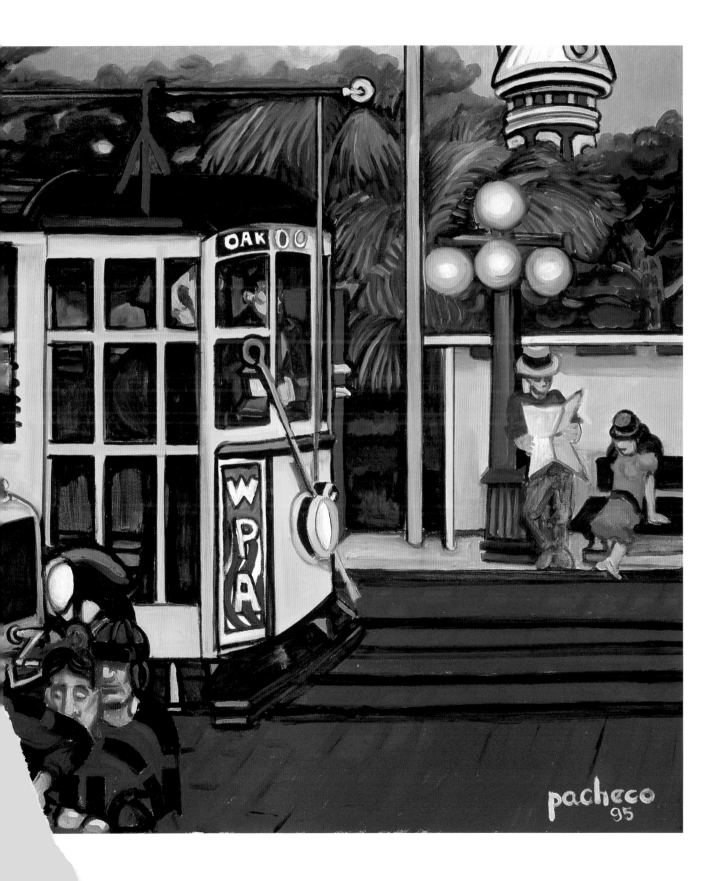

Beating the Storm to Ballast Point

1994 · 36 x 48

Here, a picnic crowd sets off to Ballast Point for a nice Sunday outing only to get caught in one of Tampa's sudden, late-afternoon thunder storms. The Tampa Bay area is famous for its precipitous changes of weather. Passengers could leave downtown Tampa in bright sunshine and arrive at Ballast Point in a downpour.

Street car no. 67 was the famous open-sided trolley that made the long trip down Bayshore Boulevard for years until the "new" Birney streetcar was introduced. In this painting, I pay homage to this old style of trolley, which was painted dark green instead of canary yellow. It was one of these open-sided trolleys that was responsible for my uncle Ralph Pacheco losing his legs, and this is another reason for my wanting to have it represented in this book.

The shed at Ballast Point was a point of shelter. The red storm-warning flag indicates high winds and rain. If four flags were raised, a hurricane was indicated. Pictured here sometime between 1910 and 1920, passengers are scurrying for the shed, losing hats, their umbrellas turned inside out, the ladies' skirts billowing up.

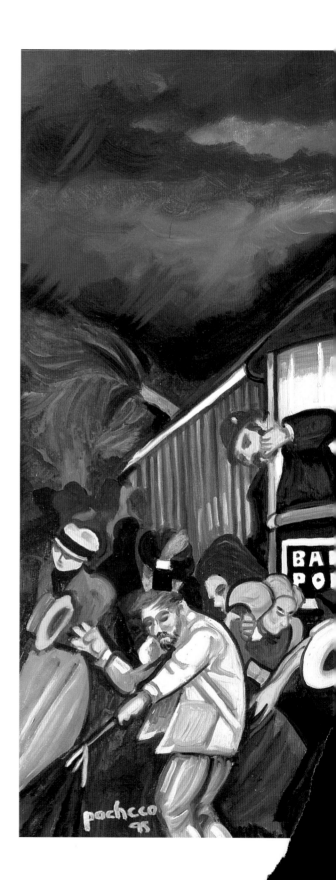

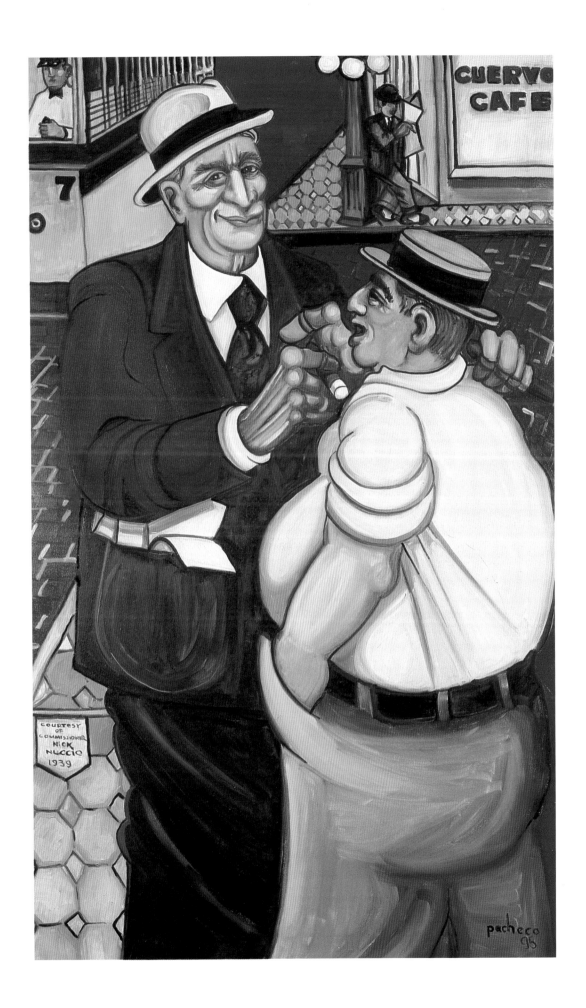

The Midway at the Fair

1995 · 50 X 72

When we were children in Ybor City, the biggest day of our lives was not Gasparilla Day, with its pirates and parades, but Children's Day at the Florida State Fair. On that magical day all the school kids from Hillsborough County were excused from school to go to the fair, ostensibly to view the exhibits of our works and to walk through the agricultural exhibits.

What we really did was head for the Midway, presented by Royal American Shows. This was an electrifying experience that defied our imaginations. Huge crowds milled about before various titillating shows. The barkers with their strange mechanical chants extolled the virtues to be seen in the freak show. Here one could view the bearded lady, the tallest man, the shortest man, the snake man, the monkey man, and the world's fattest woman. Three or four of the cast would dutifully come out front and sit in their chairs to be gawked at in open-eyed amazement.

At the very end of the long row was the flashiest of shows, Harlem in Havana. It was here that I would park myself and listen in wonder to the big bands play swing. There were at least sixteen black musicians. They did eight shows a day, and between shows they would come out front and play long, loud jazz pieces like "Sing, Sing, Sing" or "One O'Clock Jump." The leader had obviously been picked because of his uncanny resemblance to Cab Calloway. He was always dressed in the finest white suit, exquisitely tailored in the zoot suit hipster fashion. In front of the stage, couples would dance a frantic, acrobatic jitterbug. To hear a big band perform live was vastly different from listening to our 78 rpm records. To see black musicians playing with such energy and talent was thrilling. Knowing now, as I do, what kind of stamina that kind of performance requires, I marvel at the strength it took to do that gig seven days a week. No wonder they drank from time to time, and fell off the bandstand.

Every state fair has its share of test-your-manhood booths, and the best ones at the Midway were the shooting galleries and the hammer-and-gong booths. Shooting booths were magnets for soldiers and young high-school kids, who spent several dollars in the hopes of winning a little panda doll worth just a fraction of their investment.

The kids of Ybor City had another reason to attend. In most homes of Ybor City the kids ate every meal at home. Spanish and Italian cooking is superb. It was our fate to eat full meals of succulent food three times daily. What the State Fair offered us was relief from our standard gourmet diet. For once we could eat hamburgers, fat, greasy pads of meat covered with raw onions and relish and doused in mustard and ketchup. Heaven! Then there were hot dogs, similarly garnished and downed with Coca-Colas. Very few Ybor City homes permitted their children to drink Cokes. We drank milk, water, or watery red wine. I never saw a Coke in our refrigerator. Every year as we set out to enjoy the culinary delights of the fair, we could hear the ringing admonition of our fathers: "Don't eat the hamburgers. The meat is condemned and can't pass the food inspection test." Hmmm. That made it even better: forbidden hamburgers were the best forbidden fruit around.

In the background is the roller coaster, which I found I could not ride without throwing up. Witness, at the corner of the food stand, a small boy with a green face who holds his head and waits for his stomach to settle down so he can eat another hamburger. The headaches I got from Children's Day were excruciating, and most of the time I had to spend the next day in bed suffering a series of laxatives and home remedies. It was years later, when I was a doctor, that I found I was allergic to onions. And all that time I thought it was the condemned meat that was having its way with my digestive system.

In keeping with my reputation for "doing corners well," I painted my young daughter, Tina, with her friend Fiona, discovering the delights of the feathery cotton candy. Behind them a young sailor tastes the delights of young love with his Tampa beauty.

The time is 1941. Airmen and sailors (even a Russian one) can be seen mingling with the crowd. I remember my excitement at seeing two R.A.F. airmen at the fair. The Battle of Britain had just been won, and seeing their beautiful blue uniforms and unique caps

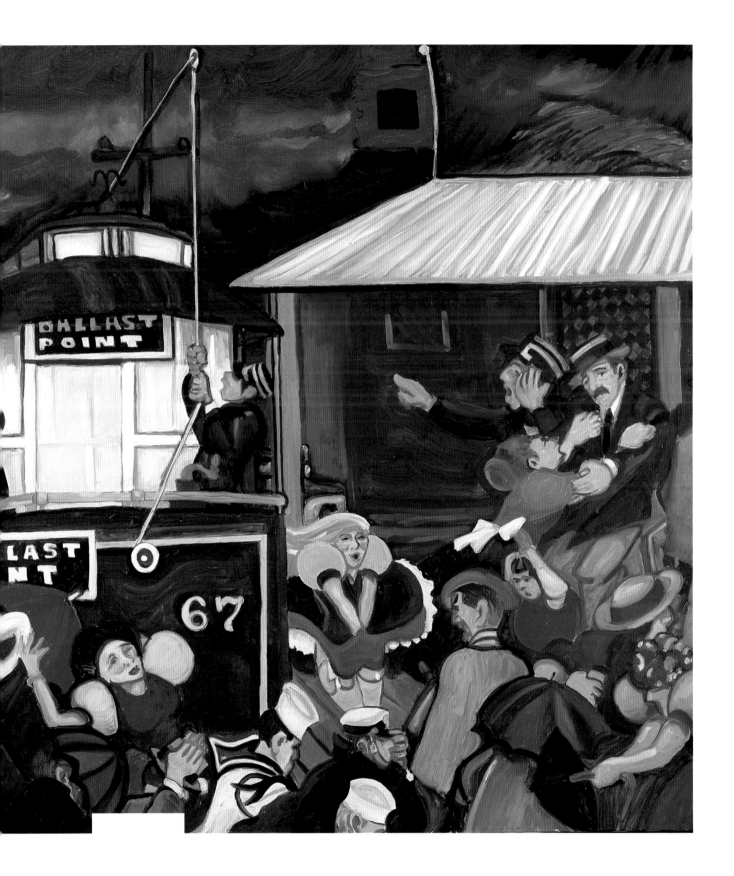

Election Day, September 2, 1935

1995 · 60 x 48

This painting boasts the longest subtitle I've ever used: "The day the governor called in the National Guard in order to protect the citizens' right to vote twice." This true-life event was called "Tampa's Longest Day" in Hampton Dunn's award-winning column for the *Tampa Tribune*. This was because during the night following that bloody election-day battle, a hurricane hit Tampa, washing the blood from its streets.

The election polls were located at Fire Station no. 2, at the corner of Columbus Drive and 12th Street. I was eight years old, and my pal Manolin Arnella called to say trouble was brewing. His father owned the Latin American Garage across the street from the fire station.

The morning had started with excitement: someone had shot a fireman who was an election official. Incredibly, this had occurred at my uncle Paul's garage, which was next to my grandfather's house at 1019 Columbus Drive, just a few houses down from the fire station.

I decided to paint this scene purely from memory. The events of that day were so sensational that they had burned themselves deeply into my young mind, and I wanted to draw only on that.

The first thing I recalled was the presence of armed soldiers. They came walking slowly down Columbus Drive, their Springfield rifles at port arms with bayonets attached, and wearing gas masks. Apparently they had used some tear gas and wore the masks as protection. For a kid who loved World War I movies and routinely pored over American Legion magazines, the sight of these soldiers was thrilling beyond words.

Then they set up a machine gun on the lawn of the fire station. The presence of a Browning .30 caliber,

water-cooled machine gun was icing on the cake. In retrospect, I wonder who they thought they were going to shoot with a machine gun. When I had finished the painting, I started to doubt my eight-year-old memory. A machine gun? Unlikely. Research uncovered the *Tampa Tribune* front page, which featured just one photo that day: the machine gun, exactly as I had drawn it. What a relief.

The battle was between Donald B. McKay, publisher of the *Tampa Times* and former five-time mayor, who wanted the county to control government and consequently its revenues, and Robert E. Lee Chancey, the current mayor, who wanted city government to prevail. Both were from prominent families and well backed.

The election was so crooked that at one point, the *Tribune* reports, the county sheriffs were arresting police officers. It was pure mayhem, and the battle raged all day and into the night as ballot boxes were stuffed, and stolen, and ballots altered. For those of you with some curiosity about historical facts, Chancey won the election. The hurricane also won, depositing tons of water on the streets of Tampa and causing millions in damages.

One final detail was wanted to finish the painting. I needed a visitor, so at the corner of the firehouse I added a man scribbling in a book while a friend looked over his shoulder. In 1935 the Red menace was very real in Ybor City. The scribbler and his friend are none other than Lenin and Stalin.

This painting was bought by Mayor Dick Greco's administration and now hangs in the City Hall lobby, a reminder of when political elections were bloody affairs in Tampa.

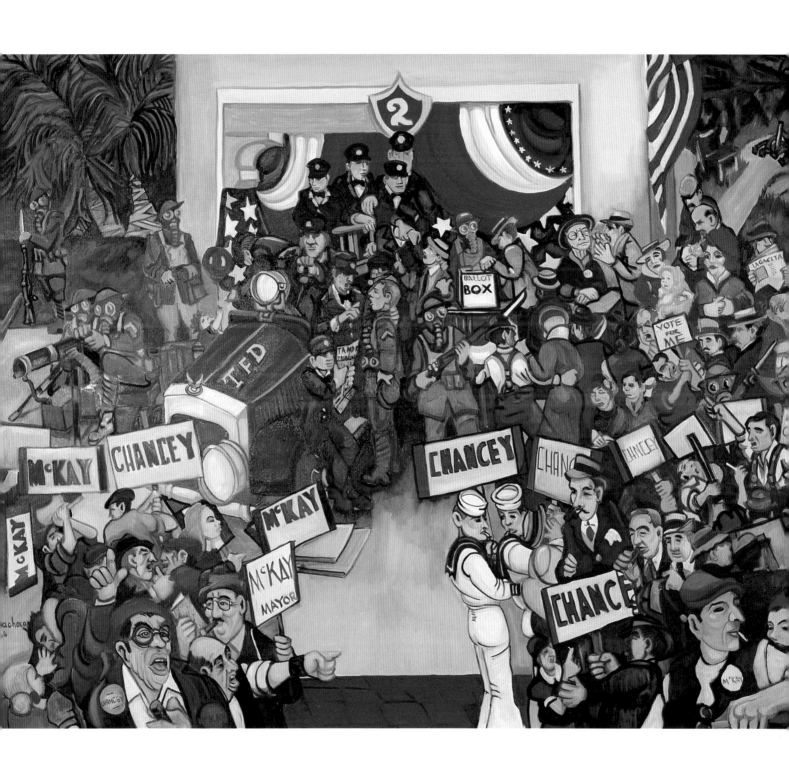

Mayor Nuccio

1995 · 60 x 36

Of all the mayors Tampa has had, perhaps none has been so popular in the memory of its citizens as Mayor Nick Nuccio. This may be because he embodied the best of the ward politicians, or perhaps it is because he was so warm and generous. Or perhaps it is because in all of his long life he did nothing but politics.

Although Nick Nuccio was born in America to Sicilian first-generation immigrants, he never quite mastered the English language. He spoke fractured English with a heavy Italian accent, and he was famous for his malaprops. An example springs to mind. When Governor Haydon Burns did something particularly nice for Ybor City, Mayor Nuccio said, "Governor Burns has a soft spot in his head for Ybor City."

Nuccio began his career serving as an alderman in the days of the corrupt Chancey administration. Ward politics was not a new phenomenon. It had been perfected in New York City by Boss Tweed, in Boston by Fitzgerald, in Jersey City by Boss Haig, in Memphis by Boss Crump, and so on. Tampa politics was a serious business, and elections sometimes became life-and-death affairs. Nuccio survived all of the corruption and violence, sailing serenely over the broiling political understrata by devoting himself to good works. He was a one-man employment service, open twenty-four hours a day, seven days a week. He was also a shameless self-promoter. He would offer a paving contractor a city contract provided the contractor would stamp "Courtesy of Alderman Nick Nuccio" in the wet pavement. Today Nuccio might get into serious legal difficulty with such shenanigans, but in those balmy days of open corruption it was looked upon as an example of Nuccio's innocently self-serving nature, his charming and naive need to be recognized. Even today everyone in Tampa thinks of Nick Nuccio as one of the few honest politicians to come out of Tampa.

Like his Italian counterpart, Fiorello La Guardia of New York, Nuccio was lovable. A rumpled man, with suits that never quite fit, ties that were too broad or too narrow, and a preposterous Borsalino felt hat perched on his head, Nuccio would walk the streets of Ybor City, his pockets bulging with the cigars he always had ready to hand to his constituents.

He would set up office at Cuervo's Café on Seventh Avenue, and while he dipped his *pan con mantequilla* in a large cup of *café con leche,* he listened to a stream of supplicants. He would make notes and stuff them in his pockets. Later, at City Hall, he would conscientiously fulfill each request. He apparently never met a man for whom he couldn't find a job in Tampa government.

Your mother was too old to take the driver's license test? She couldn't pass the eye test? No problem, he'd get her a new driver's license. What? Your son-in-law can't get a job? Send him to the Sanitation Department, he'll have a job. Your taxes were too high? He'd see what he could do.

Nick Nuccio had an answer for every request and it was never "No." He ran Tampa as if it were his family domain, and he was the all-knowing, all-good *paterfamilias.*

In this painting he strikes a familiar pose. He leans over so as to better hear the fat man's request, and has a cigar ready to give him. He has even delayed his breakfast at Cuervo's in order to be of service. The painting captures a master politician in action out on the distinctive octagon-tile sidewalks of Ybor City.

Nick Nuccio lived at the very center of Ybor in a home large enough to accommodate his beloved family. His wife was his partner in life and was fully involved in his political life. If Nuccio was giving a political picnic for 500 guests, his wife and family would pitch in and cook the entire meal in their kitchen and then help serve it.

Mayor Nuccio spent his entire life serving the public, so perhaps the deep affection of the Tampa public is well justified.

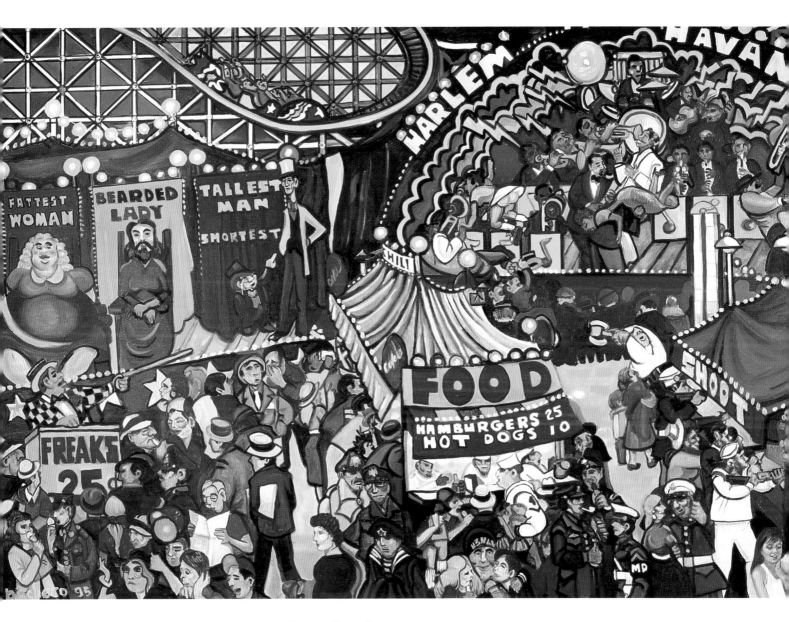

sent us military-loving kids into orbit. My "secret" in this painting is that Clark Gable is painted in his Air Force uniform. Actually, he didn't join the service until 1942, and he was assigned to Miami Beach, not Tampa, but it is the artist's prerogative to lie if he wants to.

The State Fair was discontinued in 1942 and didn't make a comeback until 1946. I went back, but it wasn't the same. Nothing ever is.

Friday at Falors

1995 · 60 x 48

After World War II ended, much of the Tampa population enjoyed the freedom that owning a car brought. One of the real pleasures was to be able to dine in the comfort of one's car. The drive-in grew out of that need.

There were four good drive-ins: the Colonnade, the Goody Goody, Falors, and the Big Orange. The Colonnade was situated on the beautiful curving drive along the bay, the Bayshore Boulevard. It was a small seafood restaurant but had a vast, deep parking lot in the back. The kids from Plant High School made this drive-in their exclusive hangout.

Downtown, the business and working people went to the Goody Goody on Florida Avenue, which had excellent food and row after row of stalls for cars. No high-schoolers went here; it was a serious place of business, and the general working population frequented this famous drive-in.

The star of the drive-ins was Falors on Florida Avenue, just a mile or two from downtown. This drive-in serviced the kids from Hillsborough, Jefferson, and Jesuit high schools—the schools the Latin kids from Ybor City attended.

Friday at Falors is a boisterous painting of teenage frolic. The front shop boasted a huge barrel marked with three stainless steel X's. This barrel held Falors' famous root beer, which could be gussied up by adding large gobs of vanilla ice cream, making an unforgettable drink called a root beer float.

In the entire town no one could make a hamburger like Falors. The owner had concocted a special sauce,

the recipe for which he doggedly refused to divulge. Even entreaties from servicemen overseas for the secret formula met with a stony silence.

The lot was deep and tapered off into the darkness, where a huge oak added to the pitch-black atmosphere. Here the lovers parked, had their late-night snacks, and stayed for hours in undisturbed, concupiscible bliss.

On Fridays during football season the players met at Falors to tell stories of their athletic prowess. Boys fought, flirted, visited friends in other cars, and spent most of the night just having a great time.

In the foreground stands the ubiquitous Chelo Huerta, now a captain in the Air Force, who has returned after a heroic few years of fighting in the air war over Europe. He has traded his red Hillsborough High sweater for the glamorous pinks and greens of an Air Force pilot. Girls flock around him, as usual, and he seems ready to take up where he left off.

Incorporated in this painting are most of the cars I have owned at one time or another, including some from my antique car days. While I was generally careful to pick automobiles that were affordable and popular, there is one car that was never seen on the streets of Tampa, and that is a 1942 Packard Darrin convertible. In those days, only movie stars and presidents owned that car, since only nine were ever made. When I got into the antique car business I bought one. I loved that car, so I decided to put it in the center of this painting. Here the owner is putting down the top as a waitress stoops to pick up a dropped Coke bottle.

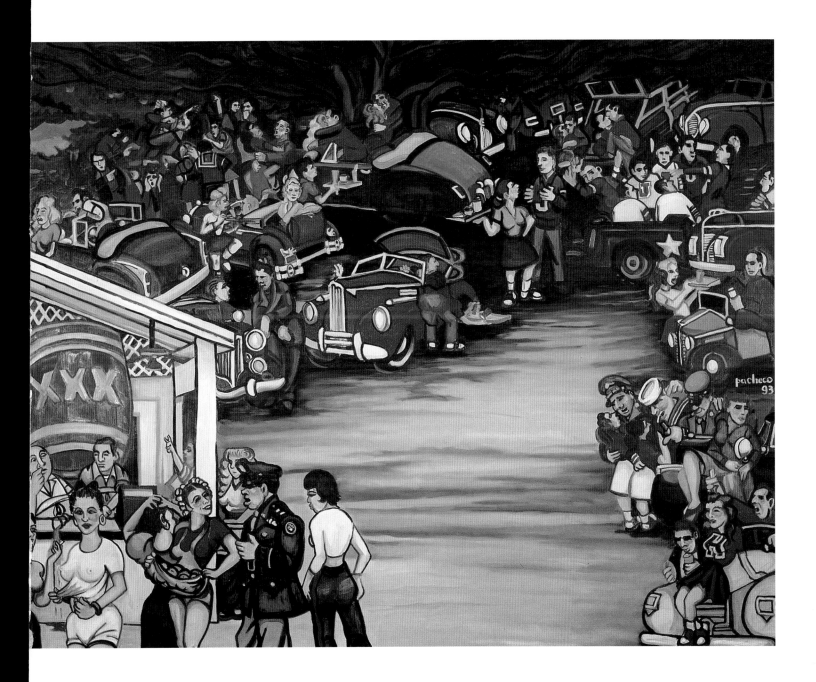

Rainy Night at the Big Orange

1995 · 36 x 30

One of Tampa's popular drive-ins was on Lafayette Street, on the "other side" of town. The Big Orange was an all-night place that served hard liquor and was populated by the post–high school crowd. The waitresses were pretty, sassy, and frequently available, provided one had the patience to wait until five o'clock in the morning.

This painting commemorates that kind of patience. The patience of a kid who is hanging around, watching from the car, waiting for a waitress to get off while a tropical storm drenches the place, ruining the night's business.

The Big Orange was actually built to look like—what else—a huge orange. It attracted a funny crowd and a lot of attention. It was also the drive-in of choice for that intermediary cast of character—the bachelor. As we aged we took on the drive-ins in stages: all the way from adolescence at Falors to young adulthood at the Big Orange, and then to marriage and the end of drive-in romances. After marriage it was the Goody Goody, if you were lucky.

Current generations cannot conceive of the luxury of eating in the privacy of a car, sneaking in a kiss and a hug for dessert, and of being in the company of an entire lot full of friends. I do miss the conviviality of the drive-ins, but I miss the hamburgers of Falors even more.

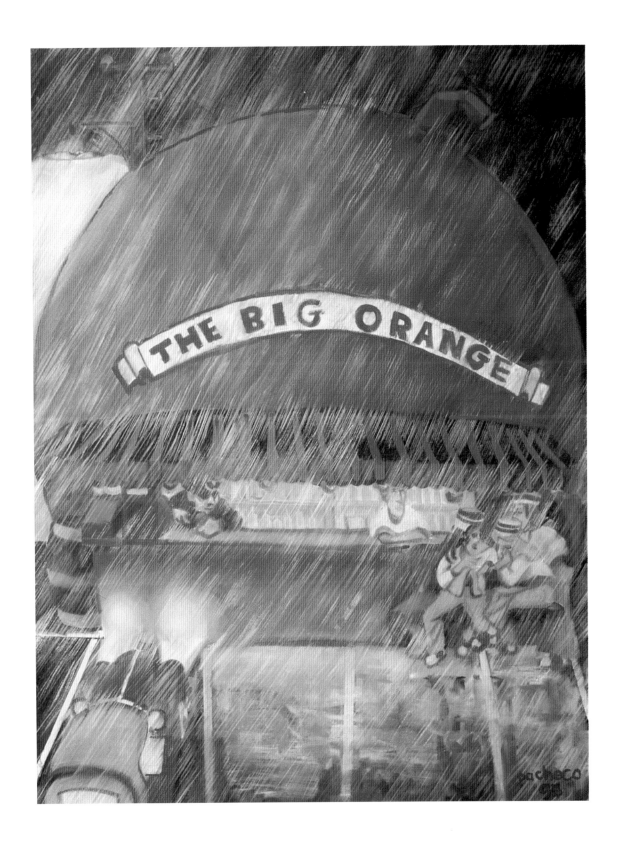

Colando Café: The Breakfast

1995 · 24 X 24

In this scene I capture my family's kitchen at breakfast time. My intention was to show what daily life was like in an average Spanish home in Ybor City.

The primary element of any Latin breakfast was Cuban coffee. In the days before expresso machines, coffee grounds were boiled on the gas stove and then poured through a *media,* or sock. The sock was invariably white, and it rested on a stand, although many chose to pour with one hand and hold the strainer with the other.

This was a job exclusively handled by my mother, for she did not trust my brother and me to pour it lest we spill the messy black grounds on the table. She was astute in her misgivings; every time I tried it, it was a guaranteed disaster. The coffee had to be made fresh, strong, and steaming hot. At the same time, milk had to be brought to a boil, to which a pinch of salt was added. It was then ready to be poured into the coffee. Each person had his own taste. My father and I preferred it *obscuro,* very dark, and therefore, I assumed, very macho. My brother liked it half-and-half, and my mother and grandmother preferred it *clarito,* very light. In my entire life at home with my family, I never saw anyone deviate from the way they drank their coffee. I tried them all, when no one was looking, but stuck to *obscuro* because my father drank it that way, so I assumed it must therefore be the right way.

We had no refrigerator in Ybor City in the early 1930s; we used iceboxes. These were big, blocky objects made of thick wood and lined with tin. The ice went into the top compartment, and the bottom compartment of the ice chest held perishables and food items. Iceboxes required minimum care and were very practical. Moreover, they gave us the pleasure of chipping away at a new block of ice (delivered daily) with a pick. My brother and I reveled in chewing or sucking on the resultant slivers. Nothing is quite as refreshing and tasty as chomping on fresh ice. It is just one of the wonderful things phased out with the advent of modern refrigeration. Ice cubes taste like nothing compared to slivers from a freshly delivered block of ice.

If *café con leche* (coffee with milk) was the most important element of our breakfast (*desayuno*), then toasted Cuban bread was at least the next most impor-

tant thing for us. Cuban bread was delivered to our house every morning at dawn. Every doorway had a nail, and the delivery boy would leave the long loaf of bread hanging from the nail. When we got the loaf it was fresh, the crust golden brown and crunchy. My *abuelita* (grandmother) Carmen would get the gas oven warm and then toast the bread. When it was just the right temperature, she would cut it into sections, then cut these longitudinally and spread on fresh, rich butter before serving them. We would pounce on these pieces of bread, dunk them in the coffee, and try to finish ahead of everyone else so we could have the left-over round tips of the fresh bread.

My father was a pharmacist and always came to breakfast dressed for work. My mother and grandmother always rose early and dressed for breakfast. We were not allowed to come to the table without being washed, combed, and fully dressed. There were no pajamas, bathrobes, or undershirts downstairs at my house. I remember my shock at spending the night with an Anglo friend and seeing the entire family in nightclothes, sitting down to breakfast.

The four-burner gas stove was standard for Ybor City. It was a useful stove, and its ability to deliver a uniform, even heat added to the cook's ability to make great meals. It was of particular advantage in the making of soups. Using *only* fresh vegetables and applying a slow, even flame for several hours, the resultant soups were unmatched in flavor. Leaving the soup over a slow, simmering flame the next day heightened the flavor, and it was even better the next day after that. Each day produced a better soup than the last. Try this on a microwave and you will see why progress is not necessarily the best thing.

Under each leg of the icebox and stove was placed a soup dish filled with water. This discouraged ants and roaches and other nonaquatic insects. Under the stove was the ever-present rat trap with its tempting chunk of cheese. My first job of the day was to check the rat trap and get rid of the victim. I hated that chore, which may explain why I am not today a mortician.

Pots, pans, and utensils hung from the wall, just as they did in Spain. The floors were wood, either pine or a dark-varnished oak, and waxed.

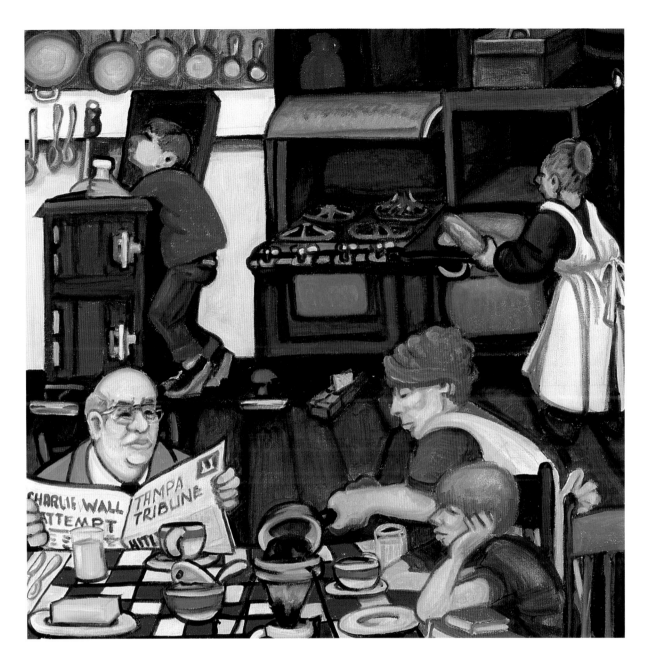

Breakfast, for an incurable optimist like me, has always been a happy time, and this painting represents some of my happiest moments, when I thought things were great and were always going to be that way. I thought then that I would always start the day with *café con leche* and *pan con mantequilla* and that my folks would never grow old.

Well, things did change, but I still wake up optimistic, looking for the good things that lie ahead, and I still have a huge cup of Cuban *café con leche* and some *pan con mantequilla*. Only now I don't have to take out a dead rat.

Matinee

1986 · 36 x 48

If the Florida State Fair was the highlight of our pre-teen school days, then most certainly the Matinee at the Centro Español on Sundays was the apogee of our social lives as young adults.

I was unable to trace the actual origin of the tea dances, and I am sure they were originally sedate, circumspect affairs at which well-dressed young ladies sat with their chaperons (*dueñas*) and waited to be asked, in a formal manner, for a waltz or a quiet *paso doble* (two-step). But by the time I came along, the Matinee was a hurly-burly of frantic dancers enjoying the wonderful big-band sound of Don Francisco.

The fun started at four o'clock in the afternoon and lasted until roughly eight. We got there on time, always. No one wanted to miss a dance, or miss lining up dances with the popular girls of the Matinee. Few girls brought *dueñas;* they came together in packs.

The dance was the main thing at a Matinee. For once, drinking and sex placed a distant second and third. People came to dance, and if you couldn't dance, you came to watch the dancers.

For a change, the most popular girls were not necessarily the beauties, but the girls who could dance the best. Of course, I am not saying that if the girl was a looker and could dance too, that she didn't go to the front of the line. She did. The same held for the boys.

There was one boy who, for obvious reasons, was called El Gordo, or Fats, who was a whirling dervish. Though huge, he had dainty little feet and an uncanny sense of rhythm. He was much in demand, a veritable Fred Astaire of flab.

In the painting *Matinee* I tried to capture the elation of the dancers, the energy of the young kids, and the happiness of the times. The scene takes place in 1945. The war is winding down, and some of the boys are back.

In one group we see again the ubiquitous Captain Chelo Huerta describing his heroics in the air war to his best friend, Captain Joe Benito, who won a Distinguished Flying Cross for his exploits in a P-47 fighter.

High-school heroes are also in attendance, proudly wearing their letter sweaters in spite of the heat. Most of the stag boys eye the girls still available, who are seated under the balcony, which held the band.

A set was structured to fit every type of dancing. First were the slow pieces, usually Glenn Miller popular songs, like "At Last," "Moonlight Serenade," or "Serenade in Blue." These were followed by a popular Latin piece, a bolero or rumba which had been Americanized, like "Amapola," "Green Eyes," or "Yours." At this point, the band could swing into a wild *paso doble,* a traditional Spanish dance which was nothing more than an old-fashioned promenade. *Everyone* danced this, even the old folks. When they got to the part where all would holler "Que viva España," the windows would rattle. Then, hot to play a fast number, the band would swing into Goodman's "Sing, Sing, Sing" or Miller's popular "In the Mood."

It was at this point that it was time to "fish or cut bait." The great dancers took over here, and the rest watched. If you wanted to walk out on the floor with a date, you had better know how to jitterbug. It was a lesson that held me in good stead through my long years of bachelorhood.

Without the Matinee, one might be lucky enough to hold a girl's hand in the movies. But at the Matinee, and particularly during a slow Glenn Miller piece, one could go into a full body press and hold a girl so tightly that the print of her dress came off on your shirt.

The finish of the Matinee was particularly memorable to me. By then a boy would have lined up the girl he wanted to end up with. The band always played Glenn Miller's "Adios," which is a truly lovely and lyrical, romantic piece. After that last enchanted dance, the couple would ride to the Colonnade for burgers and Coca-Colas. Afterwards they might park along Bayshore Boulevard, where they would watch the moon's reflection on Tampa Bay and talk about such weighty subjects as their immediate future—the next ten minutes, for example.

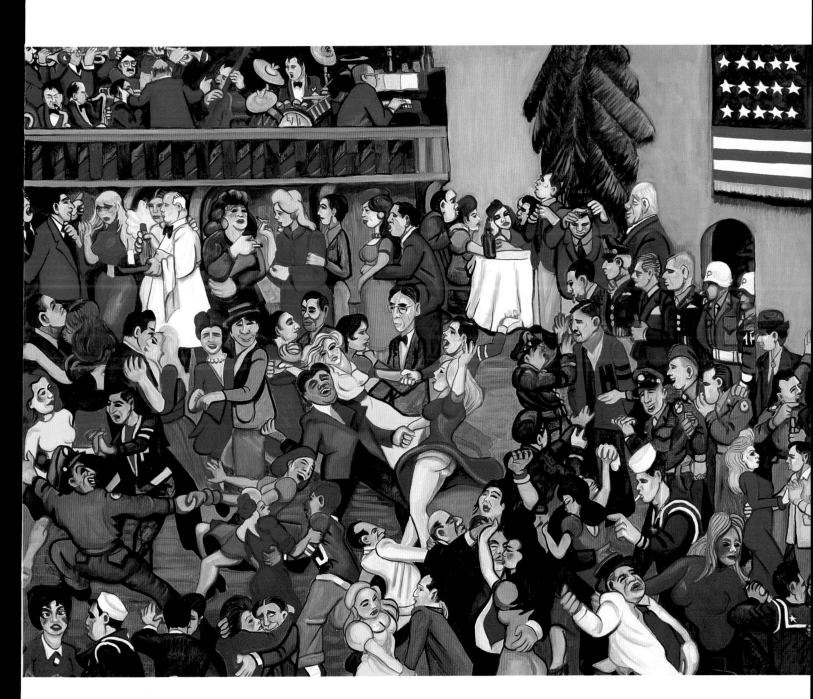

La Economica: Waiting for Papa

1995 · 48 x 36

Faced with the weighty financial obligation of putting two sons through medical school, my father decided to go back to the drudgery of owning a retail apothecary shop. He could only afford to buy a small drugstore on the corner of Columbus Drive and 16th Street.

The store was a small, clapboard building, insufficiently ventilated and lit. There was no air-conditioning, and in the summer months it became an oven. It was unpleasant, and I hated the discomfort and continuous battle against the fine dirt that swept in through the open doors and settled on all of our merchandise, thereby requiring our continuous dusting.

I was taken from my glamorous, high-paying job as a waiter at the Columbia Restaurant coffee shop to work alongside my father. The worst part of the deal was that I would not be paid. My father felt that I was exchanging a few years at the store for eight years of college, which, when I thought about it, seemed fair enough to me.

The upside of the deal was that I got to work next to my father, J. B., whom I worshipped. For the first time I would be able to help him, learn from him, and involve myself in the mysterious world of pharmaceuticals and their effects on the human body. I also learned a code of ethics, of human behavior, and of life, which would prove to be the most important bonus of all.

On the other hand, there were Sundays. My father refused to close on Sunday afternoons on the off chance that someone *might* need a prescription filled. For six months of the year Tampa is a cauldron of heat. The citizens flee for the Gulf beaches to seek relief. The ones who don't go to the beach stay in the shade of their homes waiting for sundown before venturing forth. In other words, from high noon to sundown, the streets of Tampa are empty.

All of my entreaties fell on deaf ears. The reason was simple. I was left on guard while J. B. went to the cool, marble cellar of the Centro Asturiano Club to play dominoes, or gin, or hearts with his cronies.

Sundays at La Economica felt like life in solitary at Yuma Penitentiary. Not a soul came in. Not a soul called on the phone. Everyone I knew was at the beach. Not even my mother was home. I might as well have been the only survivor of a nuclear war. I was alone.

At the end of the workday, what was supposed to happen was this: my father was supposed to relieve me at six o'clock, at which time he would loan me his 1941 Chevrolet, and I would speed to pick up a girl and spend the few remaining hours of daylight on the beach. Nothing is as romantic as holding a girl tightly in the surf while watching a beautiful Gulf beach sunset.

The afternoons spent waiting for six o'clock were desperately long. One of the talents I don't possess is the talent to do nothing. I would busy myself sweeping, dusting, restocking and then packaging the hundreds of different herbs, roots, rhizomes, infusions, ointments, syrups, leaves, and pastes that we specialized in. This done, I would go to the magazine rack, pick out the latest, and read until I had read the entire collection. And *still* there would be two hours left. An agony to be endured.

The only other victim of the afternoon doldrums was the streetcar conductor in his little yellow trolley who passed by every fifteen minutes and waved a sad hello. By four o'clock in the afternoon, even he had been relieved. I was alone.

The painting *Waiting for Papa* was born out of this anguish. So strong was the desperation I felt that I buried it deep in my memory. It took an Edward Hopper show at the Whitney Museum to disgorge it from the depth of my soul.

Edward Hopper was the master of the desolation, isolation, and loneliness of the big cities. His paintings all seem black, brown, and gray, and the canvases are either devoid of people or show people alone. My viewing of Hopper's paintings brought back those long, hopelessly dull hours when there was nothing to occupy the mind and a sense of desperation predominated.

The absolute worst part of the ordeal came when the magic hour of six o'clock arrived, and the Regensberg Factory clock tolled the wonderful six bells. Then my desperation intensified with each passing minute, for I knew that my father had no regard for punctuality, and I was at the mercy of his whim. If he was winning he would be obliged to stay for "one last hand," as a courtesy. If he was losing he would stay to try to make up his losses. It was a Catch-22.

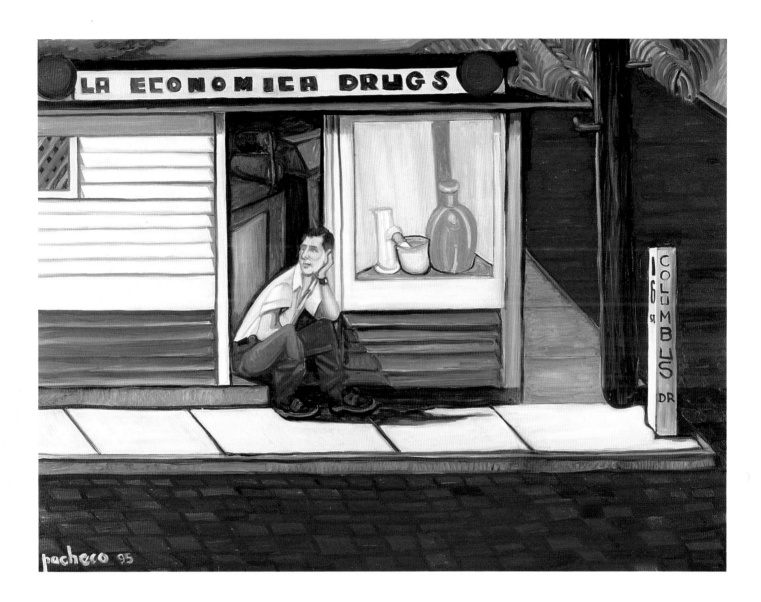

I would sit on the stoop trying to catch a breath of air, my eyes glued to the distant horizon where the two trolley tracks converged to a point. Nothing moved. Every fifteen minutes a spot of yellow would appear, eventually magnifying into a trolley. No J. B.

This painting catches the late afternoon sun, the lengthening shadows, and the stillness of empty streets. The red brick of the streets frame the dull, white and green, tiny clapboard shack that was the Sunday prison called La Economica Drugs.

Reclining Damsel

1995 · 48 x 36

As a lifetime student of female pulchritude, I have come to the conclusion that Latin women are among the most attractive. Their jet black hair, smooth, silky skin, almond black eyes, and full mouths make them the most desirable and attractive to me. Of course, this has a lot to do with the fact that I've been surrounded by them all my life. Beauty, after all, is in the eyes of the beholder. It is a subject not open to debate. Each of us has his own ideal. Mine is the Latin beauty.

After a lifetime of painting, I found I had not captured the look, the attractiveness of my ideal beauty on canvas. Since what I sought was so elusive, I had not really tried. What I was after was something hard to define, an essence, the moment when a girl becomes irresistibly beautiful.

One of the problems in painting beautiful women is they have been exposed in such overwhelming profusion in movies, commercials, and print ads that they have become commonplace. I simply couldn't manage to capture the particular beauty of a woman in an original way.

Then one day I got lucky and stumbled into a perfect setup. I am fortunately married to a very beautiful flamenco dancer, and my exact idea of a beautiful face is hers. She is given to taking naps on her stomach, and at certain moments when she is awakened by a noise, her head pops up and her eyes have a beguiling, languid, come-hither look. Bingo.

The painting *Reclining Damsel* is done in a lush, rich, turn-of-the-century style. Her dress is timeless. It could be that of a 1910 Spanish woman, or a dress worn at any time in this century right up to the present date. For the purposes of this painting I needed a shock of white to highlight her recumbent figure and slash across the dark background, so her dress became a white dividing point.

The only features of her perfect face made visible are her forehead and one clear, beautiful eye. I restrained the urge to paint her full face. It would satisfy the curious, but destroy the mystery. I leave it to the viewer to guess the rest.

There are very few paintings I do not wish to sell. They are too close, too personal to part with. *Waiting for Papa* is one, and this is the other. With these two paintings I leave my daughter, Tina, my impression of who her parents were.

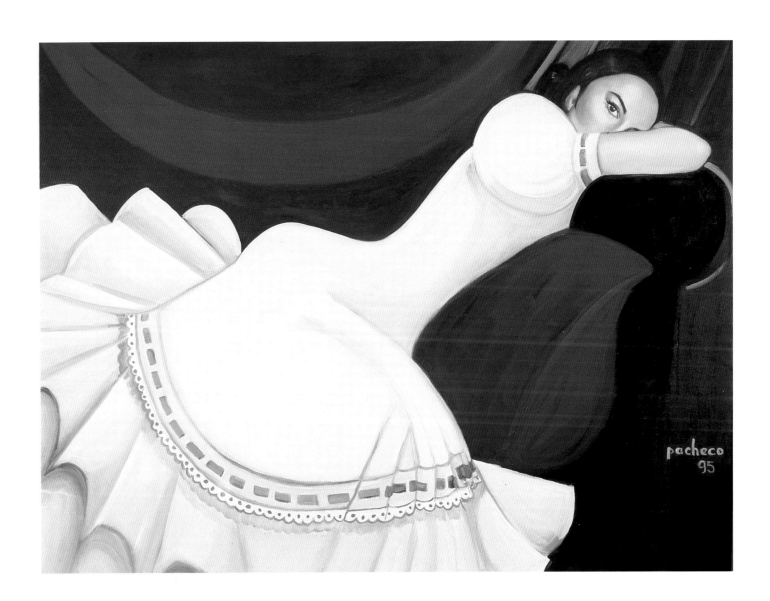

The Piruli Man

1994 · 36 X 30

One of the greatly awaited events of the long, hot summer days was the arrival of the piruli man. He came, walking slowly, his shoulders hunched over with the weight of carrying a large pole, which held 150 delicious pirulis. We had our pennies ready. He handed out his treasures slowly, one at a time, making a big ceremony out of putting each penny in his pocket. He never said a word. The only sound we ever heard from him was the sound his whistle made as he arrived at each corner. Naturally his whistle was loud and distinctive: the sound it made was "PI-RU-LEEEEE." Hence, you see, the name.

A piruli was a cone-shaped candy ending in a sharp point. The cone had two colors: the pointed top was lemon-flavored and yellow, and the base was a rich red strawberry. What made the piruli so special? Well, before refrigeration, one could only have strawberries when they were in season. With the piruli we could have strawberries year round.

Piruli is a congealed syrup, shaped in a mold and then wrapped in tissue paper, which always came off cleanly and never stuck to the piruli. At the base was a double toothpick to hold it with. It cost one penny, and it lasted half an hour, or, if you were reading a good book, say Zane Grey's *Riders of the Purple Sage*, it could last as long as one whole hour. Afterward, if you found you

were in piruli withdrawal, it was tough luck. Cold turkey. You had to wait until the next day.

When I began to record the happy days of my childhood in Ybor City, it occurred to me that no one knew exactly who the piruli man was. No matter where I went, no one knew.

One morning, while I was having my *café con leche* at the Tropical Sandwich Shop, a man sat down and solved this great mystery for me. I had done the math, as they now say, and I figured a man selling 150 pirulis a day could not support a wife and kids. Even if he worked seven days, and sold every last one every day, he could not possibly make more than $10.50 a week before taxes. How, I inquired, did he make a living?

"Ah, that is the story!" said the stranger, moving in conspiratorially. "The man used pirulis as a front. That was just a cover so he could go neighborhood to neighborhood selling bolita. *That* was how he made a living."

Gosh, I was sorry to hear that. I decided to include the piruli man in the book anyway, but I have pointedly left out his bolita pad and pencil. And, parenthetically, I wonder who his most satisfied customers were . . . I bet that at a penny apiece, pirulis in hand, it was us.

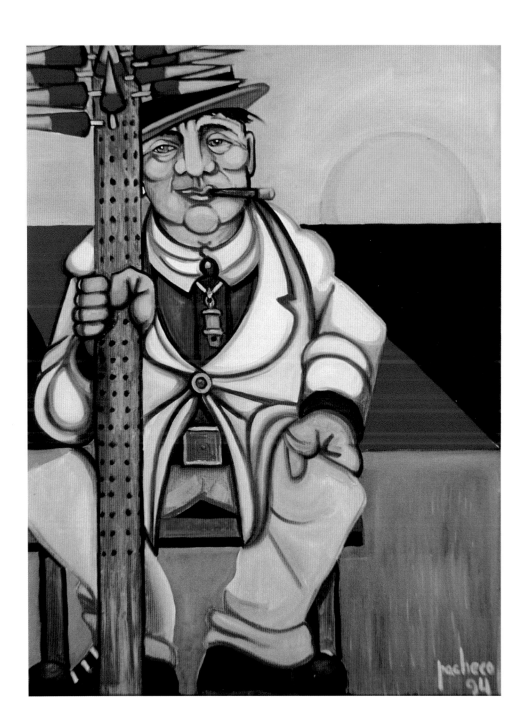

Nochebuena (Christmas Eve)

1995 · 60 x 50

The citizens of Ybor City celebrated Christmas Eve above all holidays. Christmas itself was not a big celebration, because in the early days of Ybor City's history the celebrants were mostly poor. Toys under the tree were rare. Practical gifts were more common: a shirt, some underwear, or socks.

By the time chosen for the scene of this painting, the late 1930s, the religious aspect of the Christmas feast had vanished, a direct result of the Spanish Civil War. The Catholic Church had sided with Franco and the Nationalists, who were Fascists, and so Loyalists shunned religious festivities.

When I was a boy, my parents and I lived with my grandfather Gustavo Jimenez, the Spanish consul in Tampa. By the mid-1930s, Nochebuena had become the biggest holiday of the year. On this night all of Ybor City became a vast banquet hall. The citizens prepared all week, and when the dining started, all doors were open to anyone to visit and partake. It was a glorious night for the family, and especially for the children.

To begin with, we were allowed to stay up with the adults until ten o'clock, when the dining began, and in actuality we might stay up until we could not hold our eyes open any longer. We could stay in the dining room while the men of the family, "well in their cups," spun their hilarious and sometimes off-color stories. We could eat anything on the table, and eat as much as we wanted. This alone stamped the night as unusual, and made it memorable.

The preparations for Nochebuena began a week prior. For months, families saved their money to buy luxuries and ingredients for cooking a proper meal. Extra-virgin olive oil from Sicily, the proper bell peppers, garlic, paprika, pimentos, and spices of the Caribbean. Every type of *turrón* (a nougat candy made only at Christmas)—hard with almonds in a brick-like loaf or soft in an almond paste—and every type of succulent fruit was found in abundance, as were assortments of excellent bakery products and the obligatory flan, an egg custard in a heart-shaped mold.

My painting attempts to capture the uniqueness of the night, the sense of gustatory splendor, the warm feeling of family gathered around, and the sense of high occasion. All over Ybor City the scene was the same. Families who were undergoing hard financial times, or who had recently arrived from the old country, were taken in. It is safe to say that on Nochebuena in Ybor City of the thirties, no one went hungry or was left out.

Another thing that never varied was the menu. In Spanish-Cuban homes the main attraction was the pig. Cubans bought live pigs, slaughtered them in the back yard, and then cooked them over an open fire. Spaniards usually roasted two hams in the oven, but the result was the same. I saw a live pig butchered once, and it ruined my Nochebuena dinner that year. To this day I still don't feel too great about cutting chunks of pork off a carcass.

It took all day to cook a pig on a spit in the backyard. Men took turns turning it and basting it with a large brush doused in *mojo* sauce. *Mojo* made the difference. It is made in a gallon jug with sour orange juice, garlic, onions, salt, and extra-virgin olive oil. It requires hours of patience to baste a pig properly.

Meanwhile, my grandmother Carmen and my mother, Chelo, both master chefs, attacked the rest of the menu. The defining dish was black beans and white rice. The beans took time to prepare. First you hand-picked the beans on the white porcelain kitchen table. The kids took part in this. We picked out the small stones, pebbles, twigs, and inadequate beans. This task was taken with great seriousness and made us feel as if we were a part of the kitchen process.

The beans were then soaked all night. Just the right amount of onions and green peppers were sautéed in the fine extra-virgin olive oil of Sicily. Crushed oregano, ground cumin, bay leaf, and garlic were then added to the mixture, and the simmering began. An occasional but light stirring ensured that the beans remained separate and did not stick together. Later, salt and pepper were added and the covered beans cooked slowly over a low heat until they were tender and done. Meanwhile the white rice also required expert attention, for it must be served piping hot and each kernel of rice must be dry and individual, not soppy or stuck to-

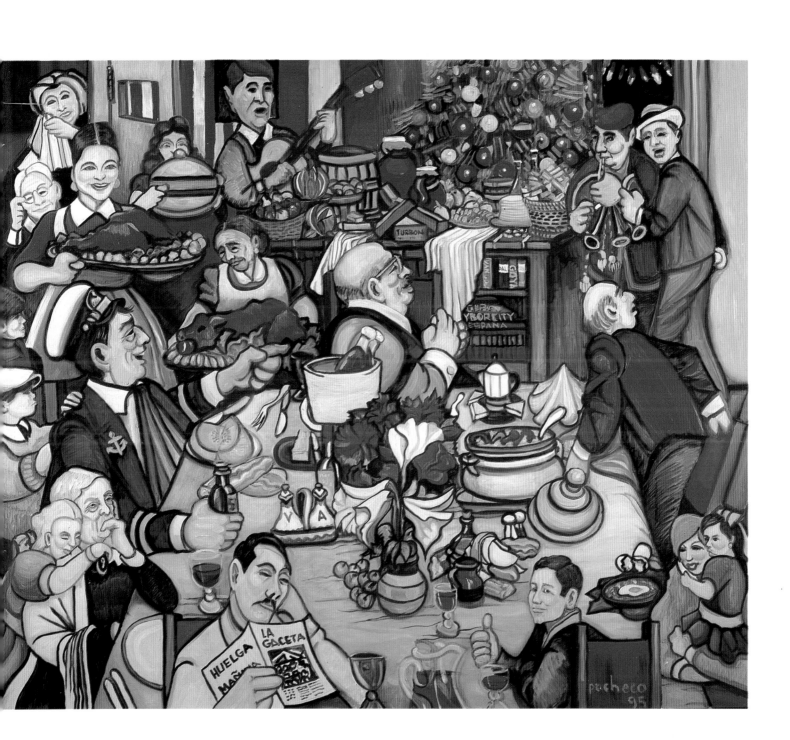

gether. White rice was served with black beans on top, then a sprinkling of chopped onions. The plantains were fried just at the moment of serving.

The meal began with soups: *caldo gallego, versada* (greens), or *fabada.* Chicken was the main dish, roasted in a sauce made of lemon, olive oil, and garlic and served with oven-browned potatoes. This was especially prevalent in Cuban households, whereas Spaniards sometimes preferred a whole red snapper (*escabeche*), and the Italians liked to serve fish and a pasta dish.

In homes with a little more financial leeway, there was turkey, too. Bowls of mashed potatoes and candied yams, Cuban yucca, *mammay, plátanos, zapote,* and rare vegetables of the Caribbean were served as side dishes.

Finally, dessert after dessert was placed on the table, along with expresso and a bottle of cognac. And then the stories would begin.

This painting captures the great culinary variety just described, as well as the sense I always had of the magical transformation of our entire house into a restaurant. Tables and dishes were set up for the kids and relatives, and unexpected visitors sometimes ate out on the front porch swing or on the stoop.

With the family gathered around, the most dramatic moment was always the entrance of the food. The women have been cooking all week, and it is their moment to be praised for the excellence and abundance of the table. I have painted my grandmother Carmen with the pork; my wife, Luisita (she wasn't born yet, but an artist can put in his painting anyone he chooses), with the turkey; and my mother, Chelo, with the *olla* (pot) of black beans.

However, if you look closely you will see that this painting also captures an unusual occurrence: this moment of culinary triumph has been ruined by the entrance of the bagpiper. El Gaitero was the only man in Ybor City who could play a bagpipe, and he went from house to house, playing a song in each. In this case, he comes at a bad moment, diverting all the attention away from the ladies.

In the foreground of the painting, one of my uncles has already had enough to drink, and it has put him to sleep. He has been reading *La Gaceta,* which gloomily predicts a strike in the cigar factories for the next day. But, since the next day is Christmas and the factories are all closed anyway, it appears that the headline is facetious.

Next to the dozing uncle, I have placed myself as a bemused observer of the scene. I have snared the jug of sangria, and my thirteen-year-old view of the delightful confusion caused by the unexpected entrance of El Gaitero is that of a typical teenager, laughing at his family's awkward predicament.

The lector is so surprised by the piper's entrance that he rises. The consul applauds the arrival, and the captain roars his approval. Even the guitarist seems startled by the noise of El Gaitero's arrival.

By the late 1930s, the time for the setting of this painting, the economic picture had brightened. The Great Depression was lifting, and we were even putting up Christmas trees.

The Christmas tree was an American touch, and Ybor City folks competed with one another to make elaborate displays. In our house one year, we had a tree that covered the entire end of the room. Under the tree was the nativity scene, beautifully carved wooden figurines from Spain. What was more, my parents had fashioned a winter wonderland of a mountain with a tunnel. A toy train ran through the tunnel and then emerged to take a sharp turn around the lake, which was made from a full-sized bathtub. On the lake tiny boats zipped back and forth, propelled by bits of sodium. There were also candle boats, which were really beautiful when the room was made dark and all the little colored lights and the light of the candles shone on the still lake. The *pièce de resistance* was the train coming out of the tunnel, a light in every car, small puffs of smoke from the locomotive, and a tiny whistle, which sounded periodically. We won a city prize for this special display, and I think my family shot its bolt on that one, for we never had another tree of that magnitude again.

In this painting, an ample Christmas tree represents our assimilation into the American culture. On the wall hangs the Stars and Stripes, and beside it hangs the red-yellow-red-purple flag of Spain's Loyalist government.

The unusual quality of a special night like Nochebuena stays with me, because during the Great Depression everything was scarce; but at this one time of the year we experienced the wonder of abundance and a sense of profound happiness. Of the many things I miss about old Ybor City, Nochebuena is the one most precious and dear to me.